NATIONAL PORTRAIT GALLERY

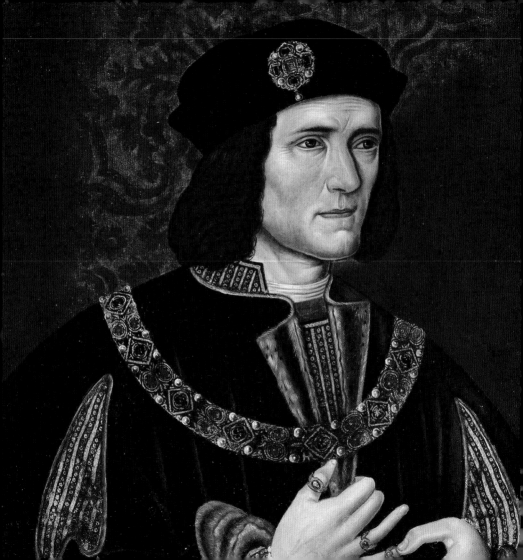

NATIONAL PORTRAIT GALLERY

100

PORTRAITS

CONTENTS

OPPOSITE
MIKE'S BROTHER
(SIR PAUL MCCARTNEY)
Sam Walsh, 1964

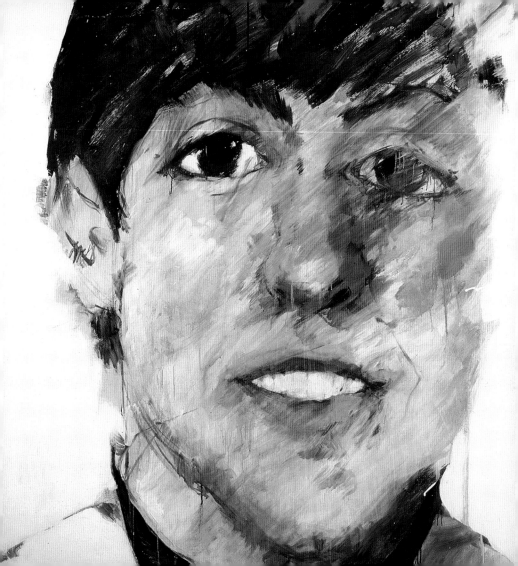

INTRODUCTION
NICHOLAS CULLINAN

If you're reading this book during your visit to the National Portrait Gallery, London, welcome to the most extensive collection of portraits in the world. If you're browsing through it at home, we sincerely hope you enjoyed your time with us and that you will return soon. Either way, the images reproduced on the pages that follow will provide you with a glimpse of the five centuries of portraits on display here, from those remarkable survivors of the Tudor period to the familiar faces of our own time.

The principal aim of the Gallery, 'to promote through the medium of portraits the appreciation and understanding of the men and women who have made and are making British history and culture', has remained unchanged since it was founded in 1856. Within a week of their first meeting on 9 February 1857, the Trustees decided on a guiding principle of 'sitter first': that the selection of works for inclusion in the Collection should be made on the grounds of the historical significance of the person depicted and not on the basis of the artistic merits of a particular portrait. Another rule required that 'no portrait of any person still living, or deceased less than ten years, shall be admitted by purchase, donation, or bequest, except only in the case of the

reigning Sovereign, and of his or her Consort' – but this was rethought in the late 1960s and today you can see the faces of many prominent living people on the walls.

Since the Gallery's founding acquisition, the famous 'Chandos' portrait of William Shakespeare offered by Lord Ellesmere, the Collection has grown steadily.

The Primary Collection currently consists of about 11,000 portraits, of which 4,000 are paintings, sculptures and miniatures, and 7,000 are works on paper. The Photographs Collection is made up of 220,000 original photographic images, of which at least 130,000 are original negatives, while the Reference Collection comprises 80,000 portraits – mainly prints, but also drawings and some paintings and sculptures.

Initially, the Collection was housed in three rooms and a staircase in an elegant Georgian town house in Great George Street, Westminster. Its custodian, the Gallery's first Director Sir George Scharf (1820–95), lived on the second floor. Despite the cramped conditions, in 1859 the Gallery allowed ticketed entry to the public two days a week and received 5,305 visitors in its first year of opening. By the end of 1869 the Collection comprised 288 portraits and its relocation to larger quarters in South Kensington saw

visitor numbers leap from 24,416 that year to well over 100,000 just six years later. Now, around two million visitors from the United Kingdom and around the world visit the Gallery annually at St Martin's Place, London – its home since 1896. Many thousands more see works from our Collection displayed in a number of locations around the country, including two properties managed by the National Trust – Montacute House in Somerset and Beningbrough Hall near York – in addition to Bodelwyddan Castle in North Wales.

Through our collection displays, exhibitions, research, learning, publishing and digital programmes, we aim to bring history to life, stimulate debate, address questions of identity and achievement, and promote engagement with portraiture in all media to a wide-ranging and increasingly diverse public. A programme of touring and collaborative exhibitions can be seen around the UK throughout the year. A large number of portraits are on long-term loan to museums and galleries around the country, and many

OPPOSITE
WILLIAM SHAKESPEARE
Attributed to 'Taylor', c.1600–10

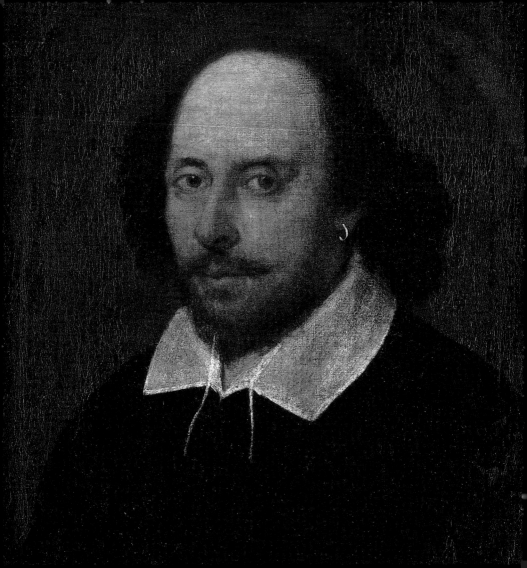

more are on show as part of exhibitions and displays organised on a short-term basis at other venues.

As the only national museum focusing on British identity, the National Portrait Gallery is uniquely placed to encourage reflection on the nature of British society, individual achievement and the impact and influence of people making a mark on the country's history and culture. We celebrate people who have in some way shaped British history, and, in so doing, show the potential in everyone to make a difference. Home to the world's largest collection of portraits, the Gallery is not only a museum of art, but also a forum for the exploration of identity, achievement and citizenship, located in the world's most diverse city.

A wide-ranging programme of exhibitions and events covering all aspects of our remit – monographic, thematic, biographical, period or medium-specific – encourages visitors to actively engage with, and foster a deeper understanding of, portraiture. The Gallery also both acquires and commissions portraits of the people who are defining Britain, depicted in all media by leading artists. We seek to take a collaborative and inclusive approach to sharing our Collection and expertise as widely as possible through programmes, digital content and publications, as well as through national and international initiatives.

The National Portrait Gallery aims to be the foremost centre for the study of and research into portraiture, as well as engaging as wide a range of visitors as possible through its work and activities. More than 200,000 portraits from the Gallery's Collection can be viewed via our searchable online database at www.npg.org.uk.

Like other national museums, the National Portrait Gallery is supported both by government and increasingly by private support, as well as by visitor donations and the receipts from ticketed exhibitions, shops, catering and events.

Through all of this the National Portrait Gallery aims to reflect both Britain's past and present, now and in the future.

NICHOLAS CULLINAN
Director, National Portrait Gallery, London

Sir George Scharf (1820–95), first Director of the National Portrait Gallery. Self-portrait, pencil and watercolour, 1872. NPG 3863

TUDOR PORTRAITS

KING HENRY VII
(1457–1509)
Unknown Flemish artist, 1505

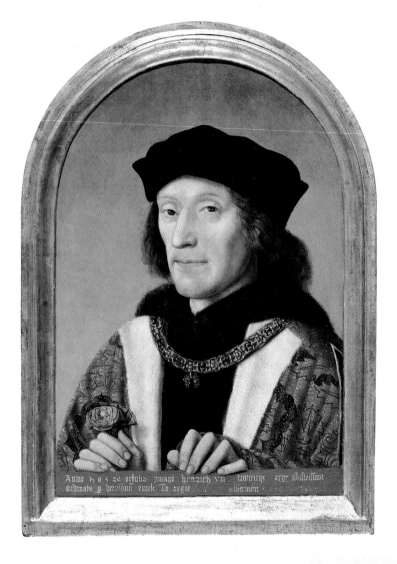

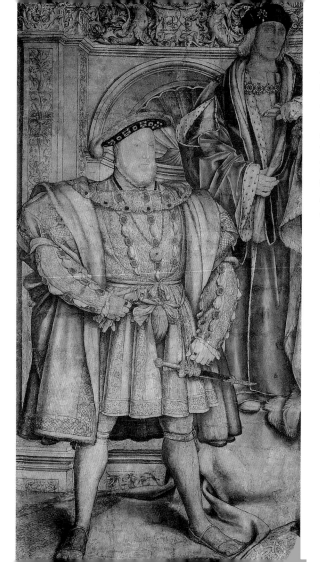

KING HENRY VII (1457–1509)
AND KING HENRY VIII
(1491–1547)
Hans Holbein the Younger, c.1536–7

THOMAS CROMWELL,
EARL OF ESSEX
(*c.*1485–1540)
*After Hans Holbein the Younger, early 17th
century after a portrait of c.1532–3*

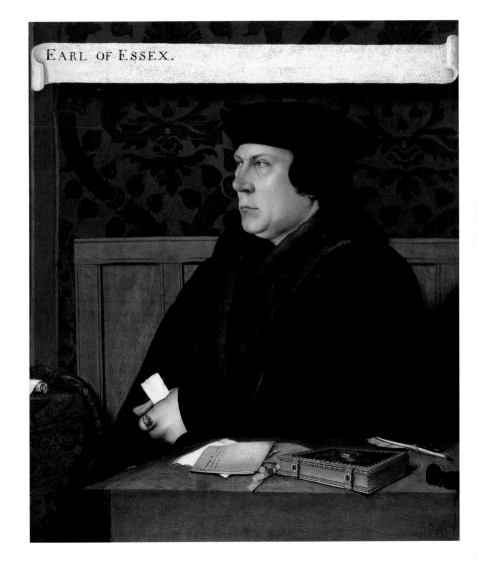

EARL OF ESSEX.

ANNE BOLEYN

(*c*.1500–36)

Unknown artist, late 16th century

after a portrait of c.*1533–6*

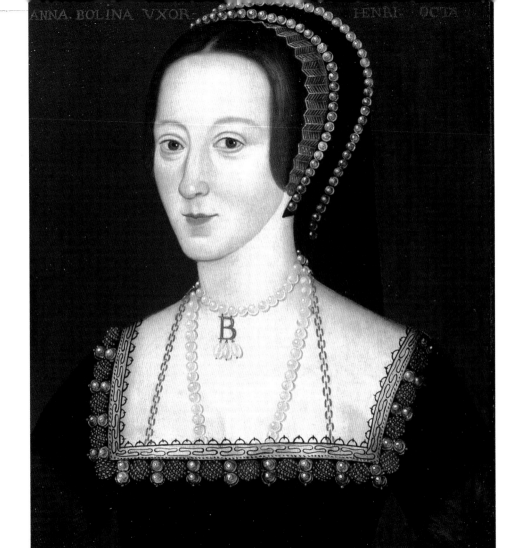
ANNA BOLINA VXOR HENRI OCTA

KATHERINE PARR

(1512–48)

Attributed to Master John, c.1545

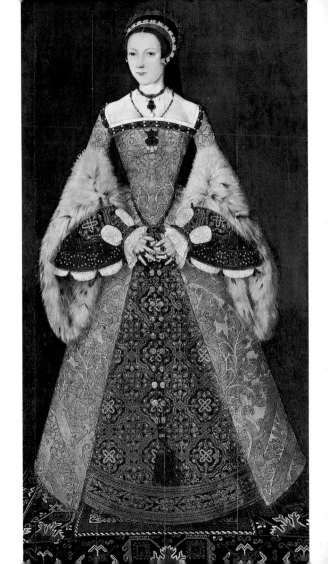

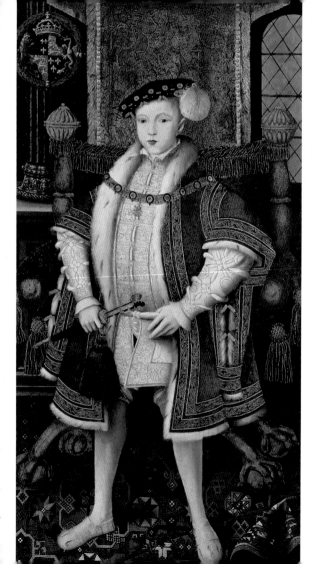

KING EDWARD VI

(1537–53)

Unknown English artist, c.1547

QUEEN MARY I
(1516–58)
Hans Eworth, 1554

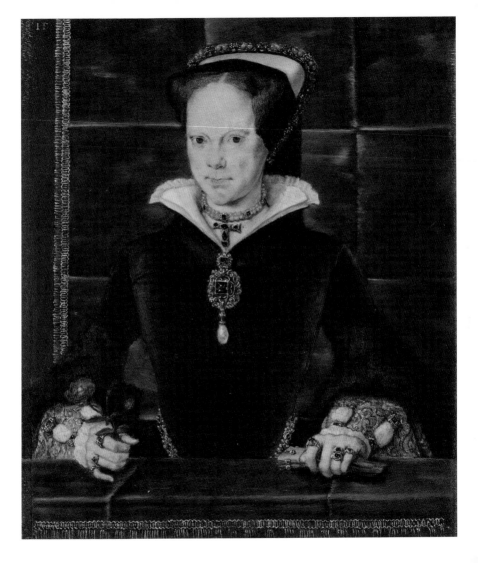

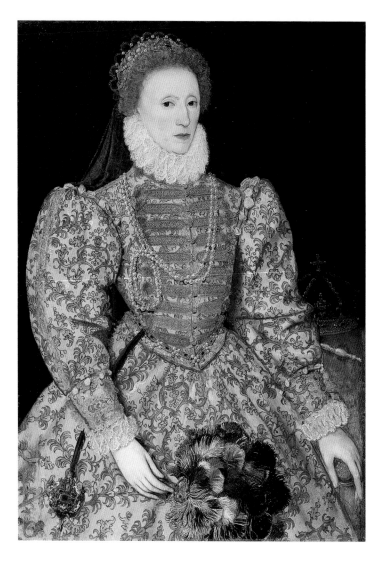

QUEEN ELIZABETH I

(1533–1603)

Unknown Continental artist, c.1575

SIR WALTER RALEGH

(1554–1618)

Unknown English artist, 1588

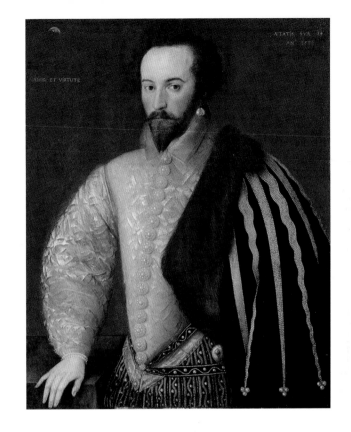

MARY STEWART, QUEEN OF SCOTS

(1542–87)

After Nicholas Hilliard, late 16th century

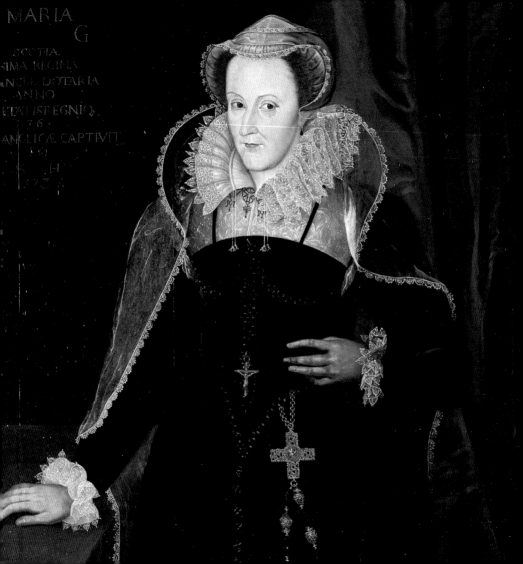

MARIA

G

SCOTIA
SIMA REGINA
NDE DOTARIA
ANNO
ETATIS EGNIQ.
·36·
ANGLICÆ CAPTIVIT
S H
·73·

STUART PORTRAITS

BEN JONSON
(1573?–1637)
Abraham van Blyenberch, c.1617

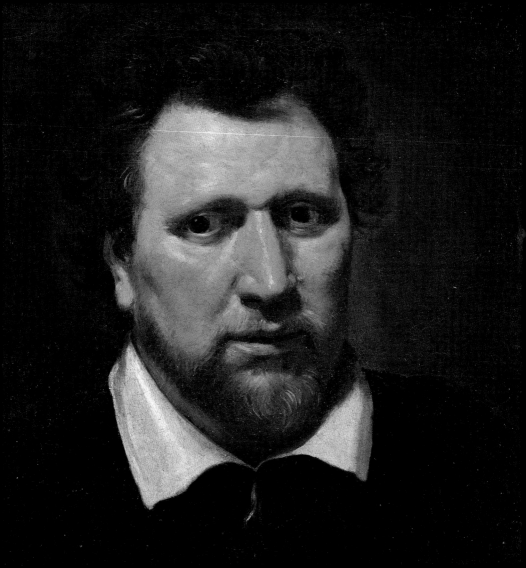

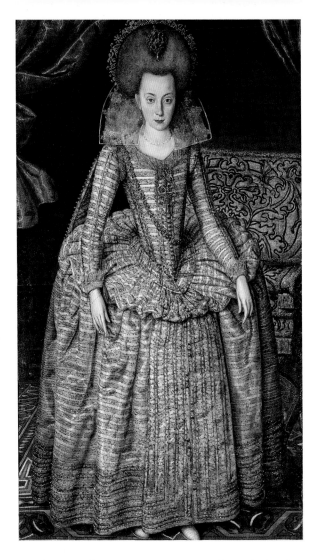

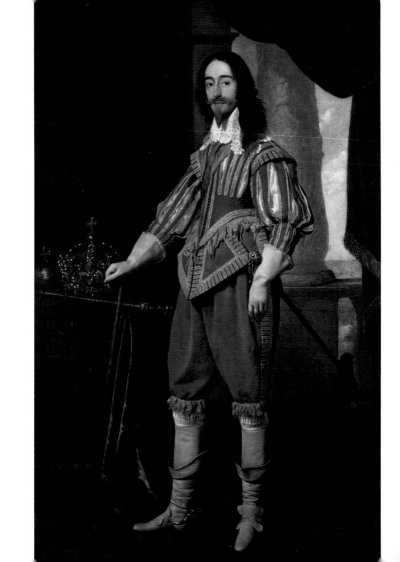

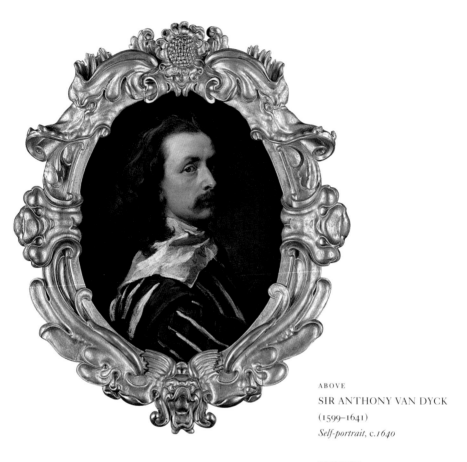

SIR ANTHONY VAN DYCK
(1599–1641)
Self-portrait, c.1640

OPPOSITE
SAMUEL PEPYS
(1633–1703)
John Hayls, 1666

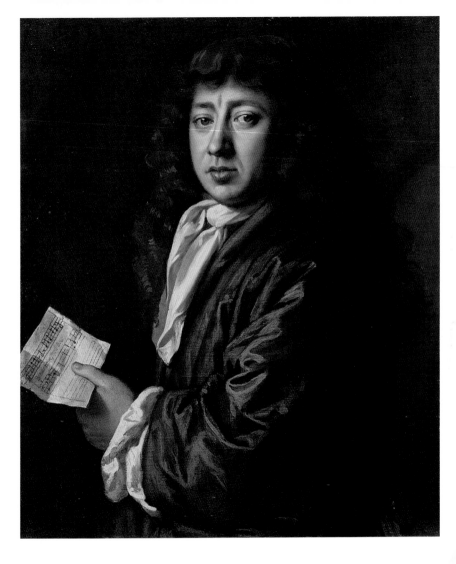

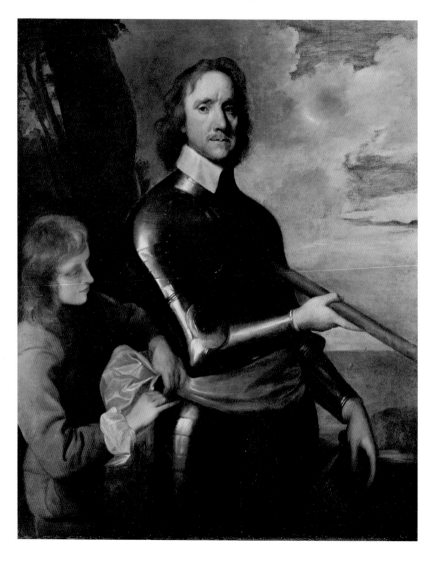

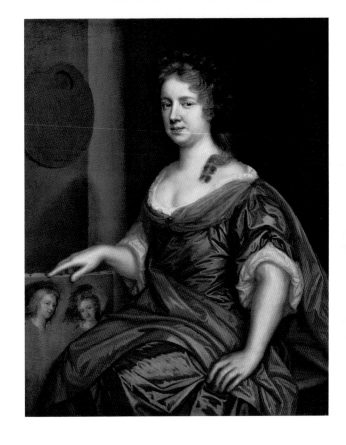

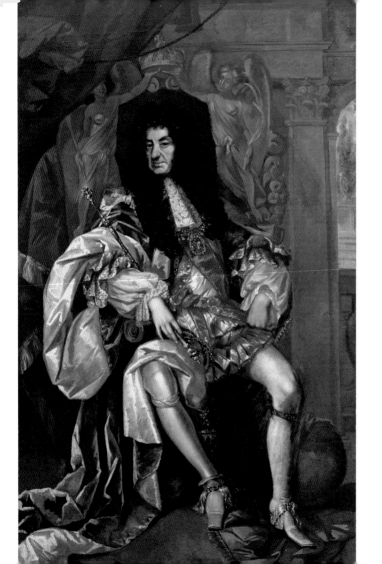

NELL GWYN
(1651?–87)
Simon Verelst, c.1680

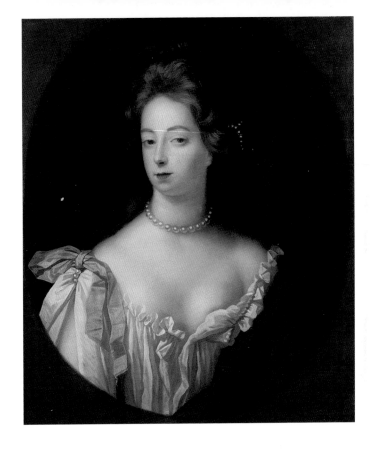

KING CHARLES II
(1630–85)
Attributed to Thomas Hawker, c.1680

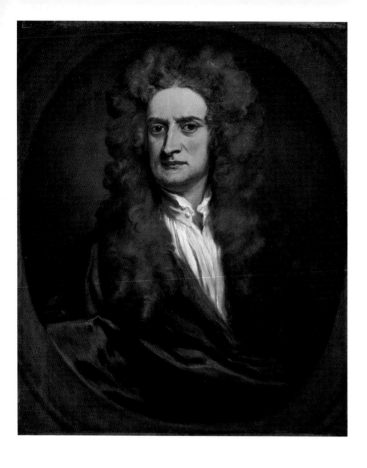

SIR ISAAC NEWTON
(1642–1727)
Sir Godfrey Kneller, 1702

OPPOSITE
HENRY PURCELL
(1659–95)
John Closterman, c.1695

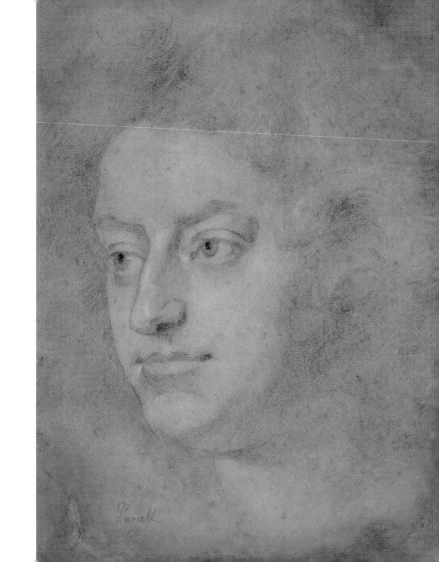

Purcell

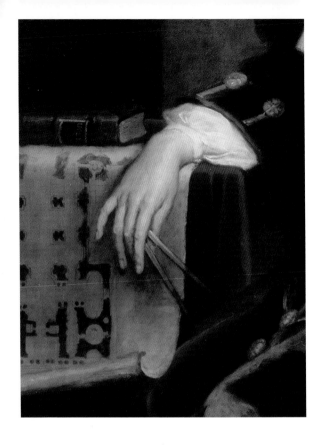

SIR CHRISTOPHER WREN
(1632–1723)
Sir Godfrey Kneller, 1711

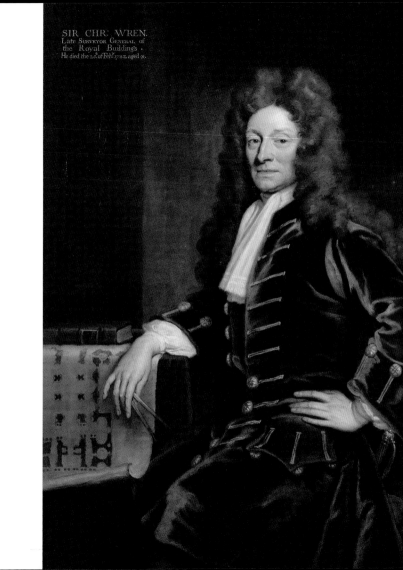

SIR CHR: WREN.
Late Surveyor General of
the Royal Building's.
He died the 25.th of Feb.y 1723. aged 91.

GEORGIAN PORTRAITS

SIR JOSHUA REYNOLDS
(1723–92)
Self-portrait, c.*1747–9*

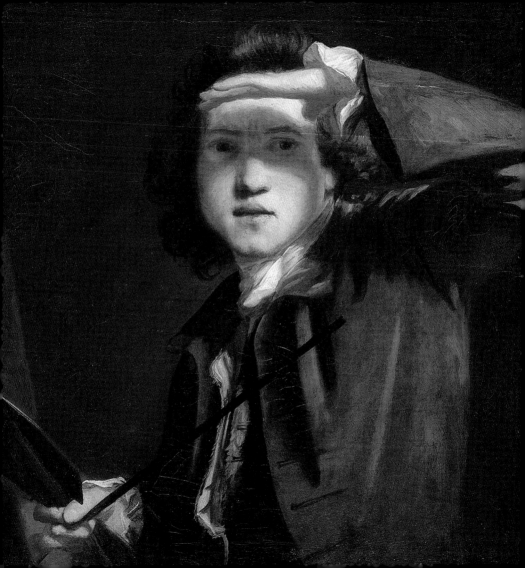

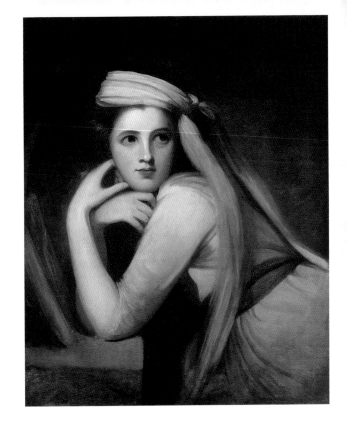

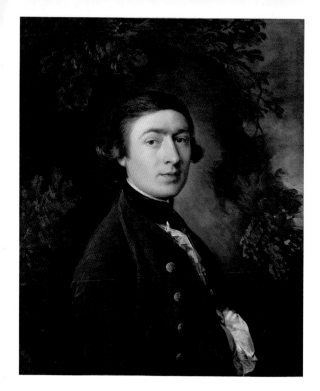

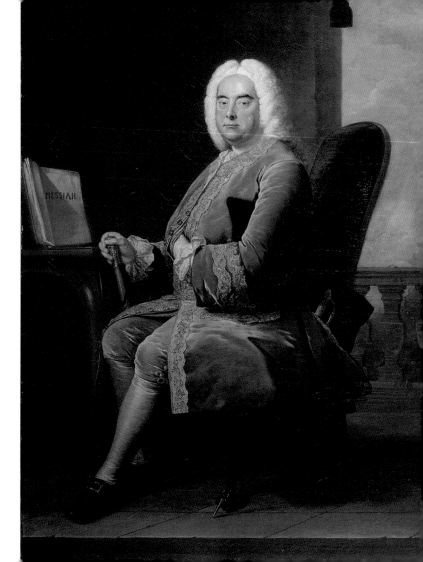

CHARLES GENEVIÈVE LOUIS AUGUSTE ANDRÉ
TIMOTHÉE D'EON DE BEAUMONT
(CHEVALIER D'EON)

(1728–1810)

Thomas Stewart, after Jean-Laurent Mosnier, 1792

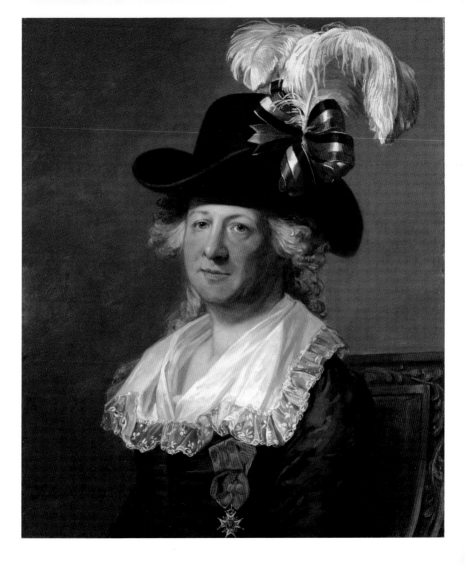

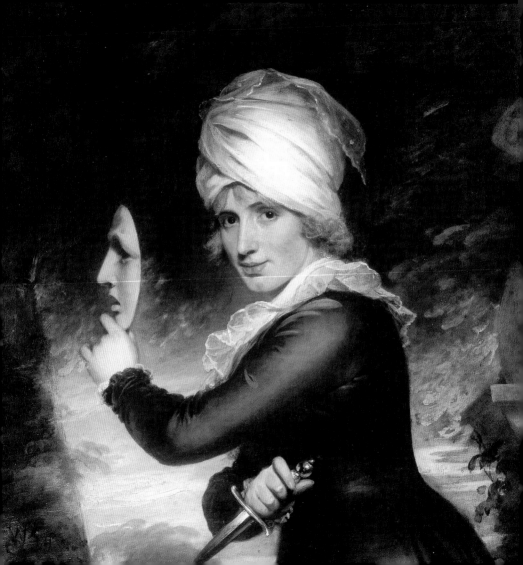

SARAH SIDDONS
(1755–1831)
Sir William Beechey, 1793

JOHN CONSTABLE

(1776–1837)

Ramsay Richard Reinagle, c.*1799*

OPPOSITE

MARY WOLLSTONECRAFT

(1759–97)

John Opie, c.*1797*

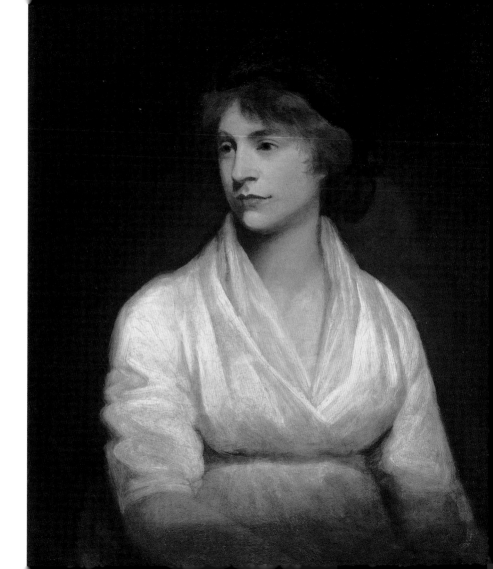

HORATIO NELSON, VISCOUNT NELSON

(1758–1805)

Sir William Beechey, 1800

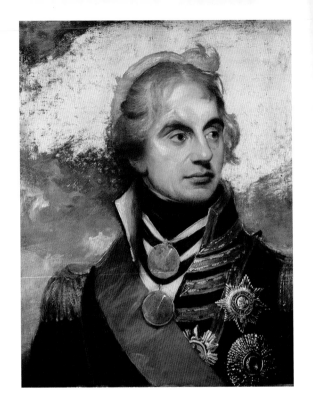

OPPOSITE
WILLIAM BLAKE

(1757–1827)

Thomas Phillips, 1807

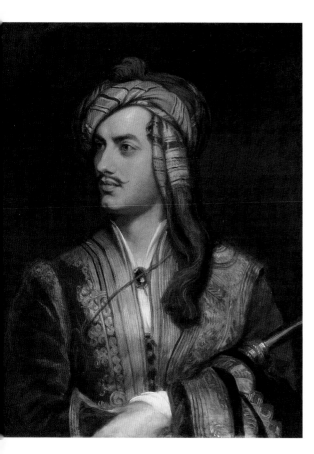

LEFT
GEORGE GORDON BYRON,
6TH BARON BYRON

(1788–1824)

Thomas Phillips, 1835

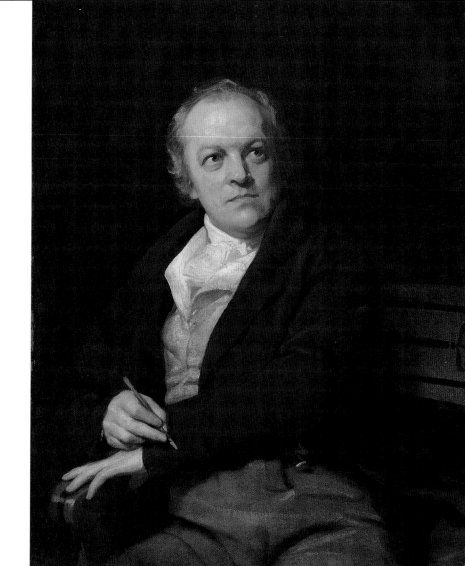

JANE AUSTEN

(1775–1817)

Cassandra Austen, c.1810

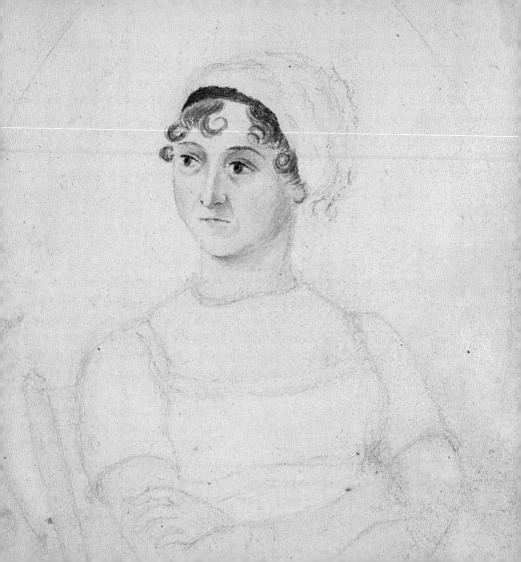

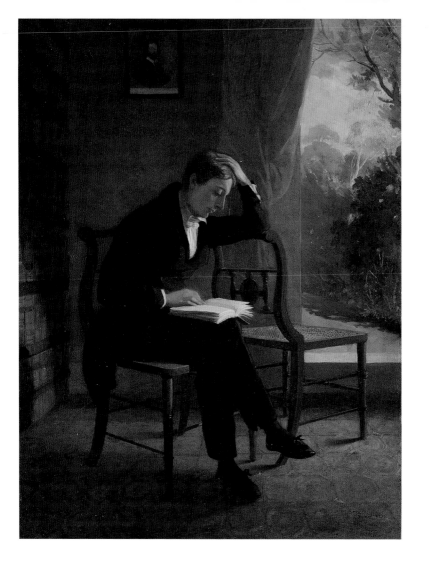

OPPOSITE
JOHN KEATS
(1795–1821)
Joseph Severn, 1821–3

BELOW
PERCY BYSSHE SHELLEY
(1792–1822)
Amelia Curran, 1819

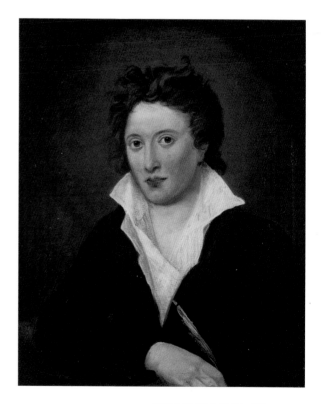

WILLIAM WILBERFORCE

(1759–1833)

Sir Thomas Lawrence, 1828

IRA ALDRIDGE

(1807–67)

After James Northcote, c.1826

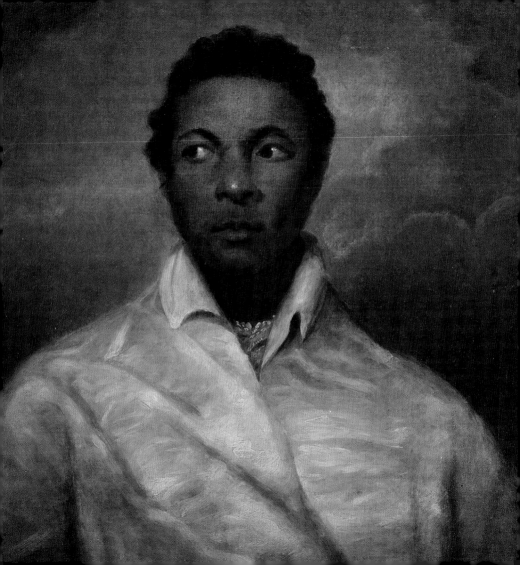

VICTORIAN AND EDWARDIAN PORTRAITS

SIR JOHN HERSCHEL
(1792–1871)
J.J.E. Mayall, c.1848

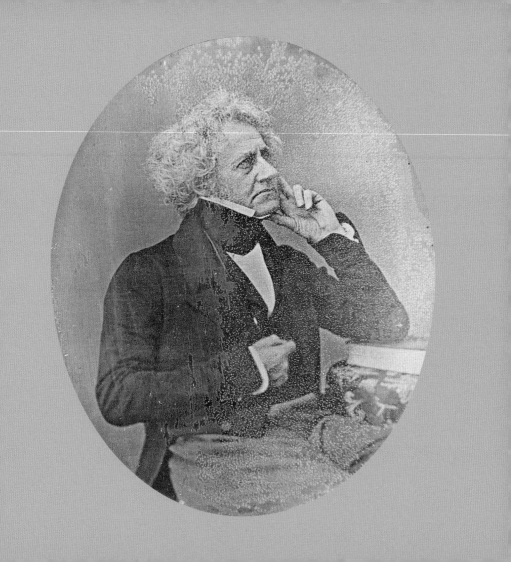

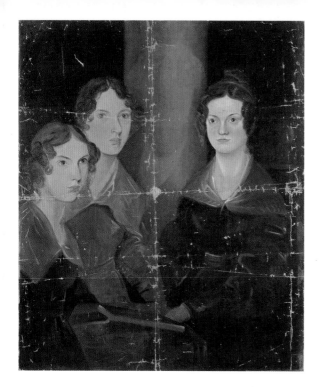

THE BRONTË SISTERS
(ANNE [1820–49], EMILY [1818–48],
CHARLOTTE [1816–55])
Branwell Brontë, c.*1834*

CHARLES DICKENS
(1812–70)
Daniel Maclise, 1839

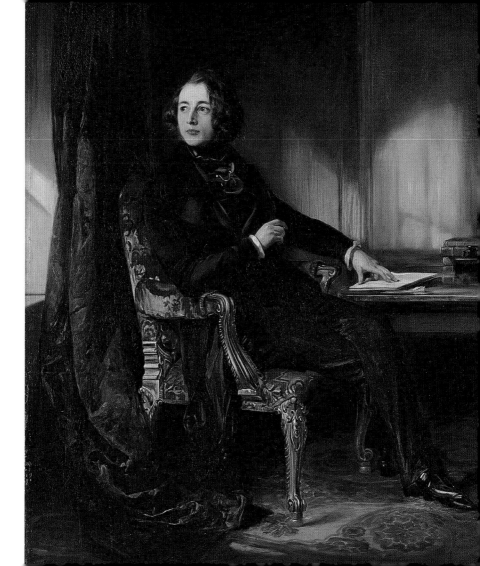

ISABELLA BEETON
(1836–65)
Maull & Polyblank, 1857

ISAMBARD KINGDOM BRUNEL
(1806–59)
Robert Howlett, 1857

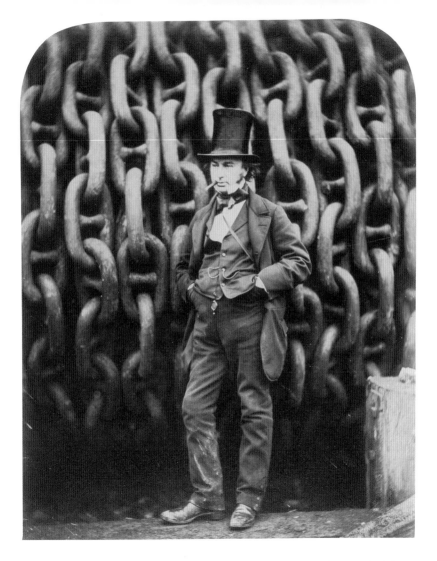

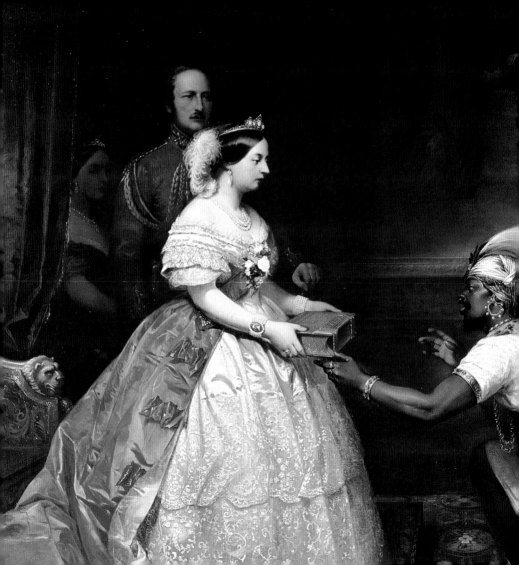

THE SECRET OF ENGLAND'S GREATNESS
(QUEEN VICTORIA PRESENTING A BIBLE IN
THE AUDIENCE CHAMBER AT WINDSOR)
Thomas Jones Barker, c.1863

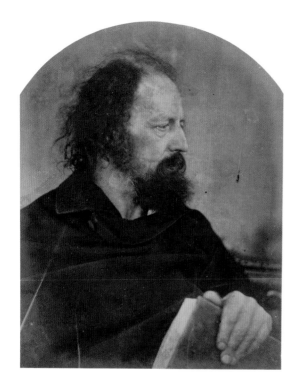

ALFRED TENNYSON,
1ST BARON TENNYSON
(1809–92)
Julia Margaret Cameron, 1865

OPPOSITE
CHOOSING
(ELLEN TERRY [1847–1928])
George Frederic Watts, 1864

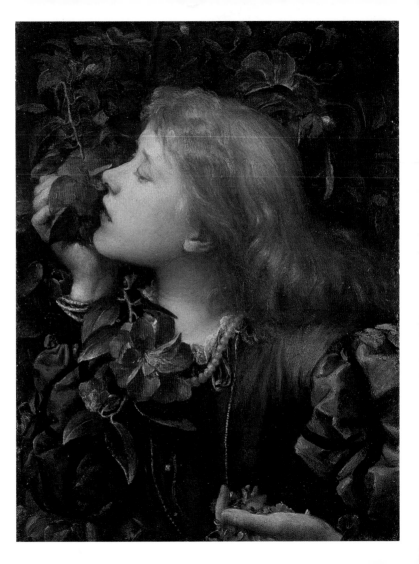

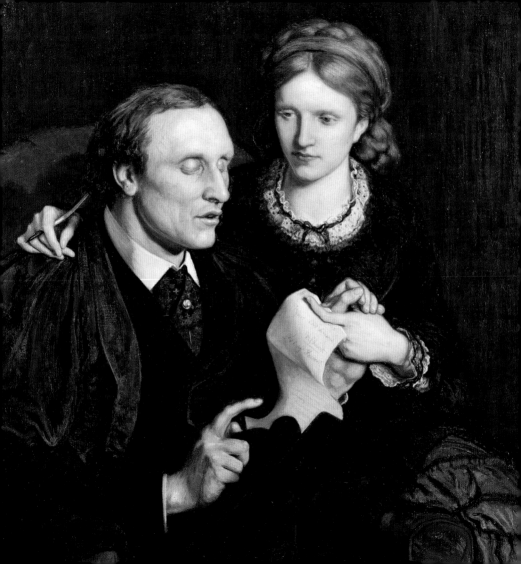

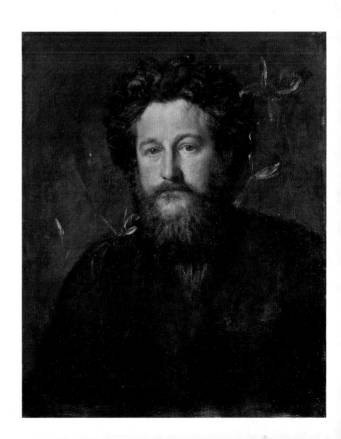

MARY SEACOLE

(1805–81)

Albert Charles Challen, 1869

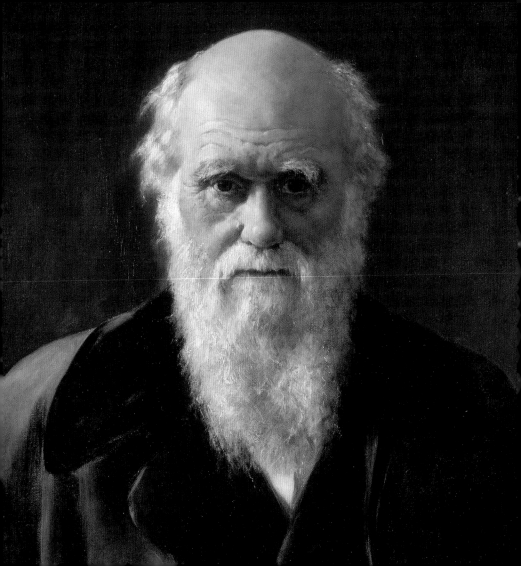

CHARLES DARWIN
(1809–82)
John Collier, 1883

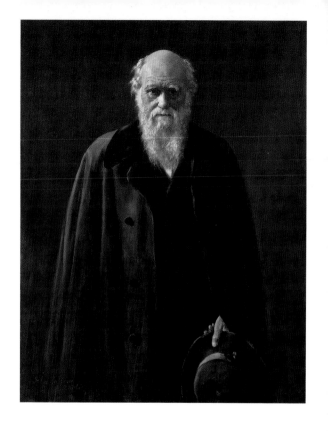

SAMUEL COLERIDGE-TAYLOR

(1875–1912)

Walter Wallis, 1881

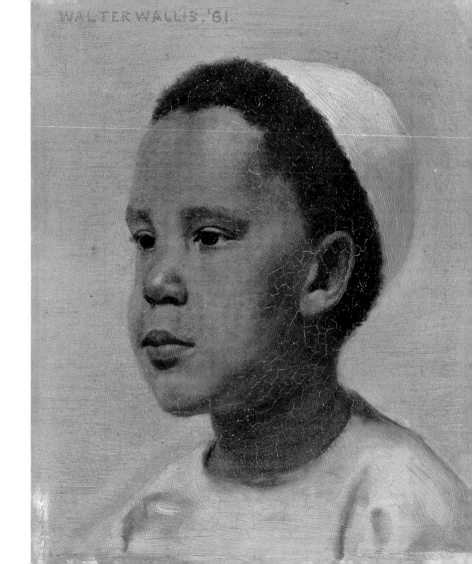

WALTER WALLIS. '61.

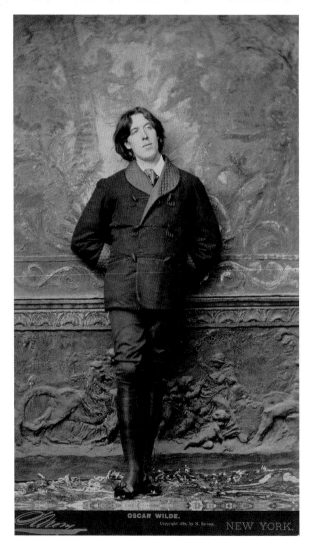

OSCAR WILDE
(1854–1900)
Napoleon Sarony, 1882

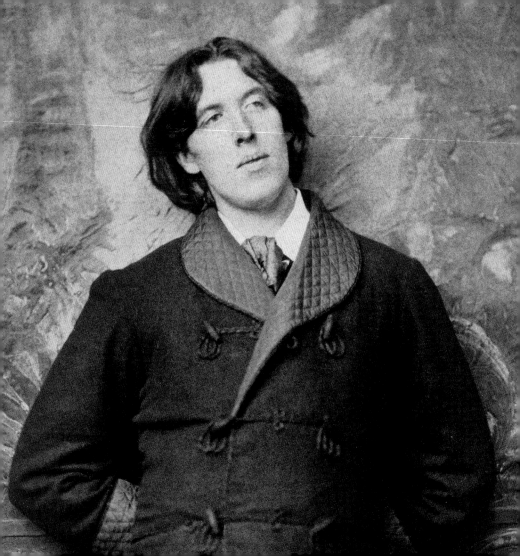

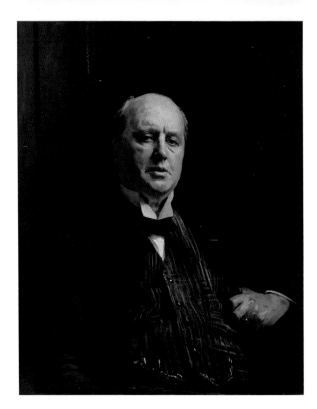

HENRY JAMES
(1843–1916)
John Singer Sargent, 1913

EDWARD CARPENTER
(1844–1929)
Roger Fry, 1894

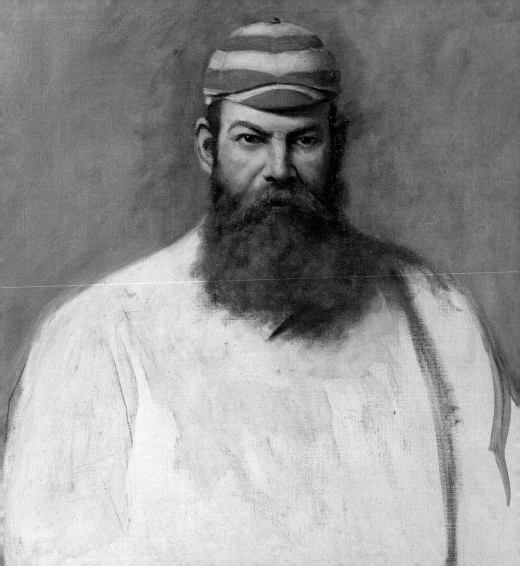

WILLIAM GILBERT ('W.G.') GRACE

(1848–1915)

Attributed to Archibald Wortley, 1890

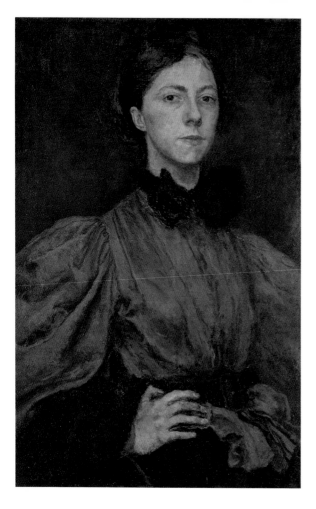

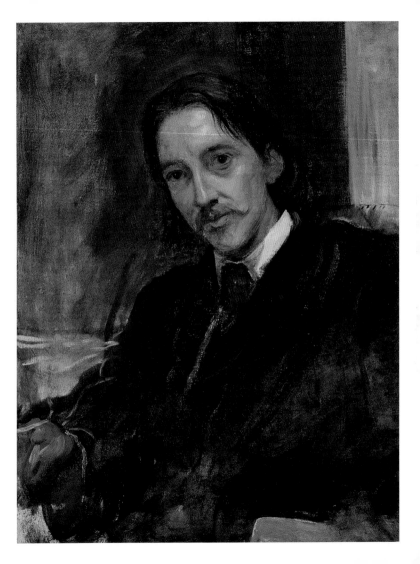

ROBERT FALCON SCOTT

(1868–1912)

Herbert Ponting, 1911

NATIONAL PORTRAIT GALLERY

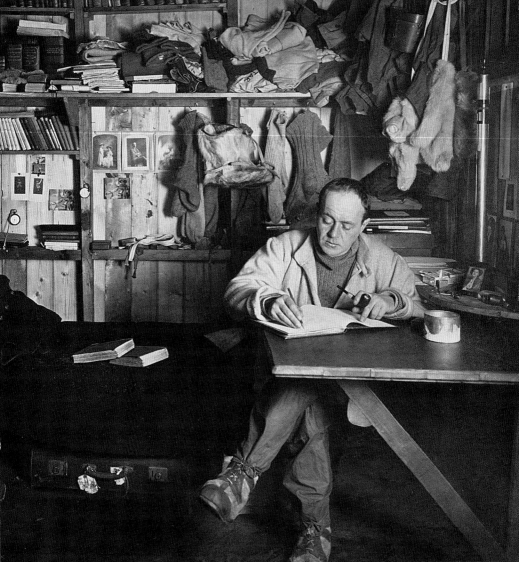

RUPERT BROOKE
(1887–1915)
Sherrill Schell, April 1913

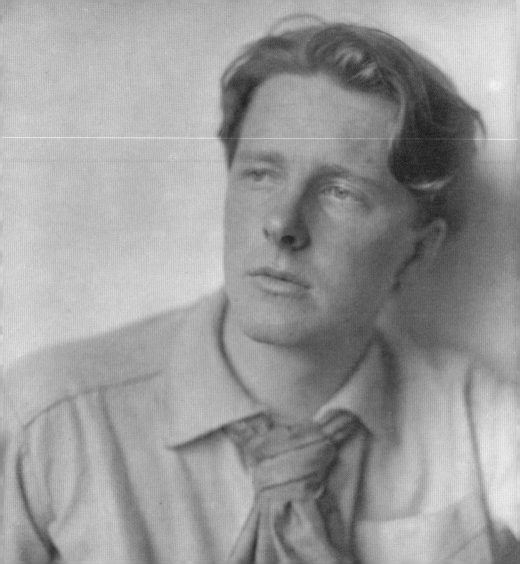

EMMELINE PANKHURST

(1858–1928)

(Mary) Olive Edis (Mrs Galsworthy), 1920s

VIRGINIA WOOLF

(1882–1941)

G.C. Beresford, 1902

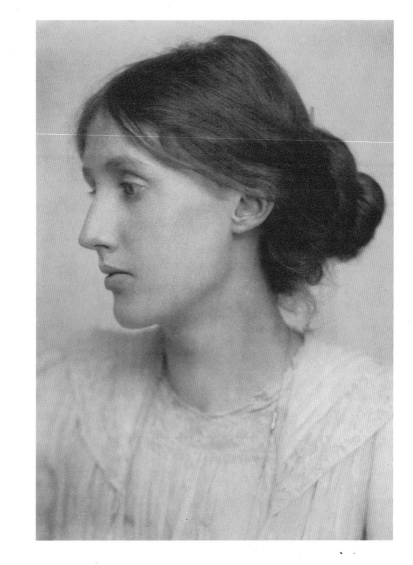

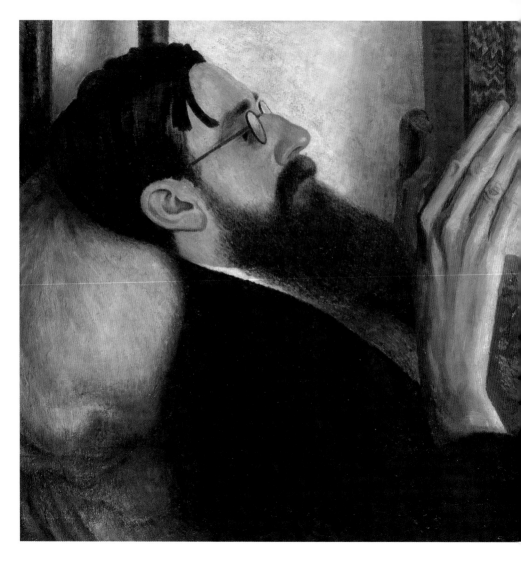

LYTTON STRACHEY

(1880–1932)

Dora Carrington, 1916

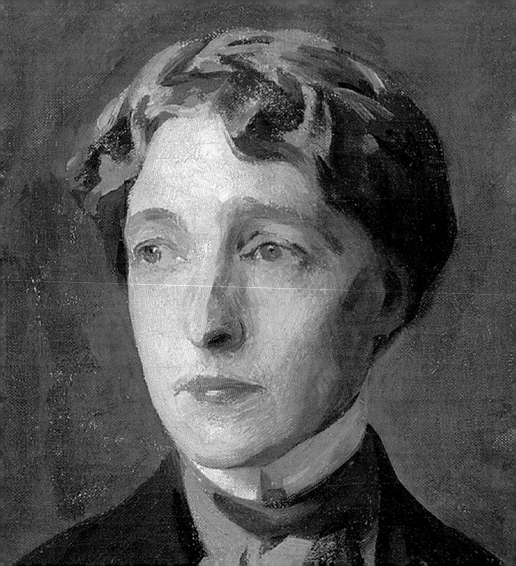

RADCLYFFE HALL

(1880–1943)

Charles Buchel, 1918

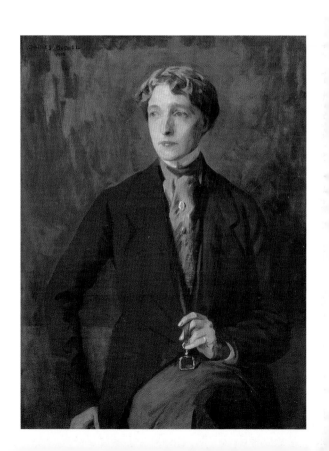

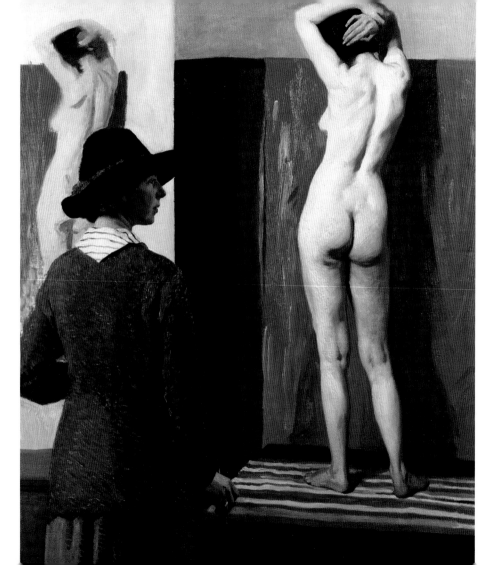

OPPOSITE
SELF PORTRAIT
(DAME LAURA KNIGHT)
(1877–1970)
Self-portrait, 1913

RIGHT
THOMAS EDWARD
('T.E.') LAWRENCE
(1888–1935)
Augustus John, 1919

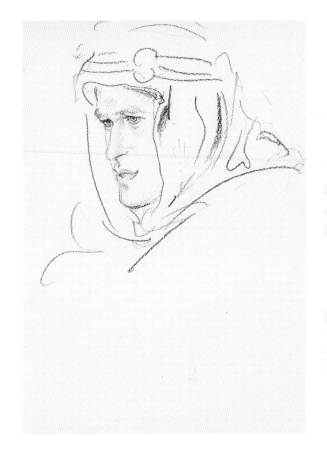

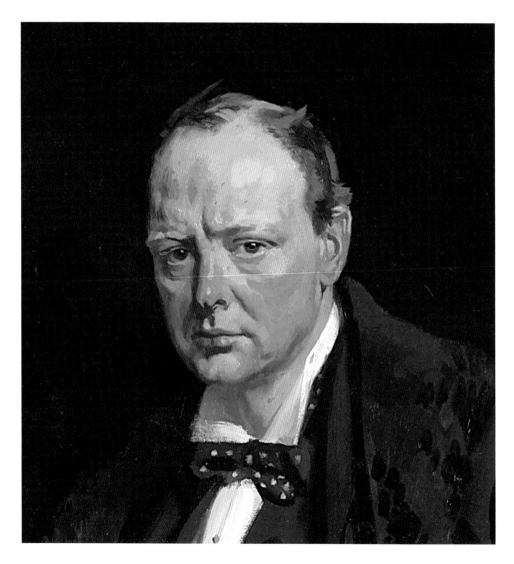

SIR WINSTON CHURCHILL
(1874–1965)
Sir William Orpen, 1916

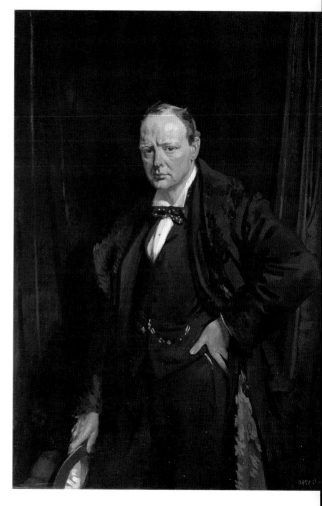

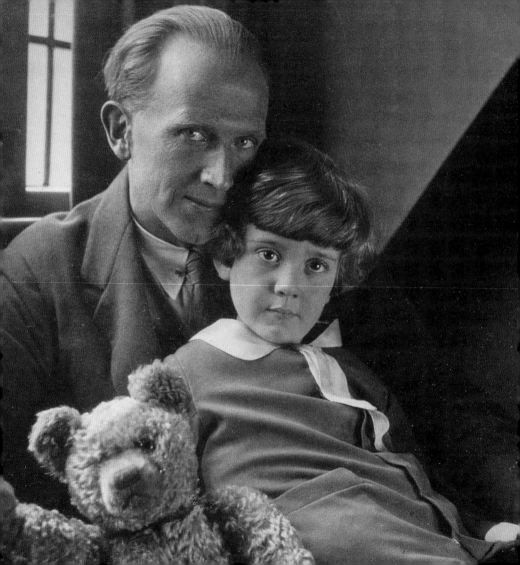

ALAN ALEXANDER ('A.A.') MILNE (1882–1956)
WITH CHRISTOPHER ROBIN MILNE (1920–96)
AND POOH BEAR

Howard Coster, 1926

ELISABETH WELCH

(1904–2003)

Humphrey Spender, June 1933

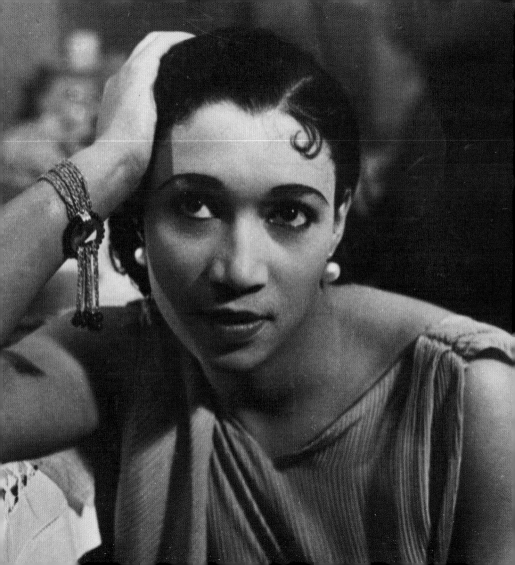

1933 (ST RÉMY-SELF-PORTRAIT
WITH BARBARA HEPWORTH)
(BEN NICHOLSON [1894–1982];
DAME BARBARA HEPWORTH
[1903–75])
Ben Nicholson, 1933

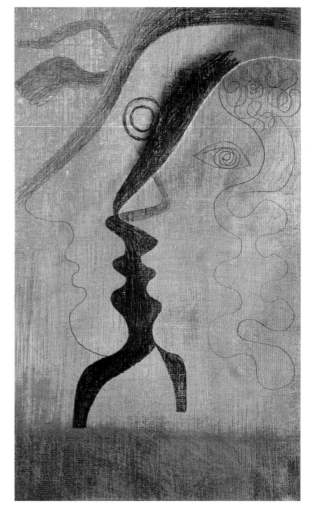

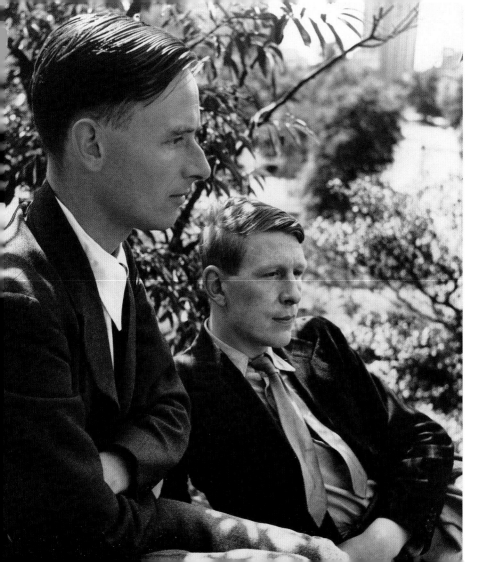

OPPOSITE

CHRISTOPHER ISHERWOOD
(1904–86) AND WYSTAN HUGH
('W.H.') AUDEN (1907–73)
Louise Dahl-Wolfe, 1938

BELOW

DYLAN THOMAS
(1914–53)
Augustus John, c.1937–8

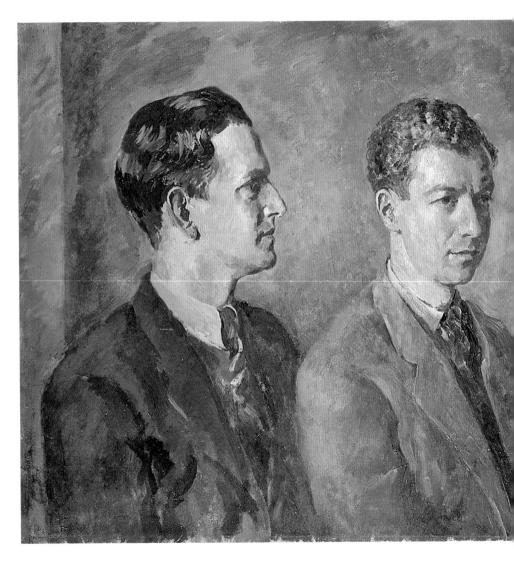

SIR PETER PEARS (1910–86) AND
BENJAMIN BRITTEN, BARON
BRITTEN (1913–76)
Kenneth Green, 1943

THOMAS STEARNS ('T.S.') ELIOT

(1888–1965)

Patrick Heron, 1949

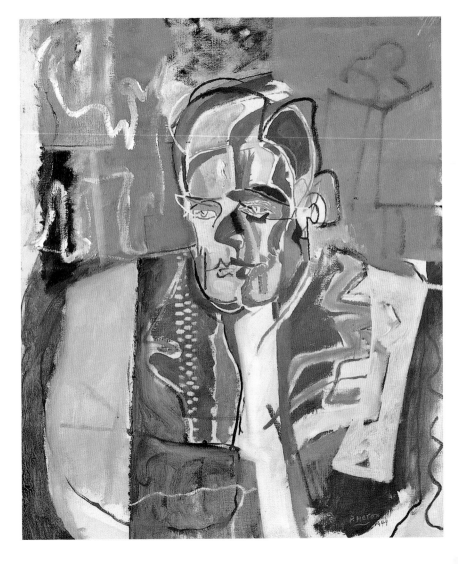

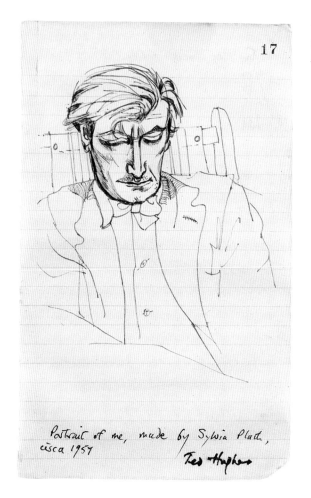

Portrait of me, made by Sylvia Plath,
circa 1957

Ted Hughes

TED HUGHES
(1930–98)
Sylvia Plath, c.1957

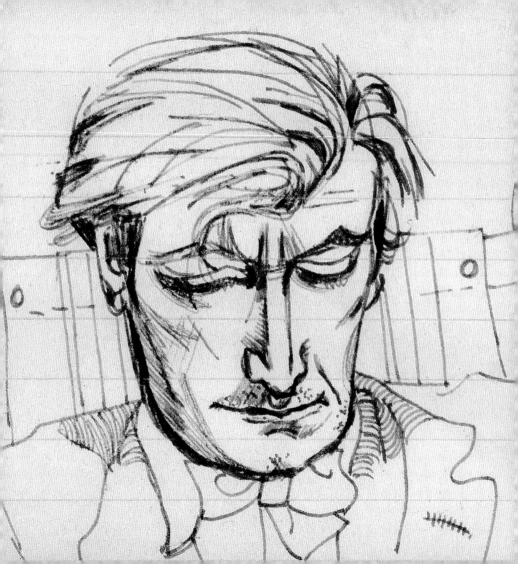

BRIDGET RILEY
(b.1931)
Ida Kar, 1963

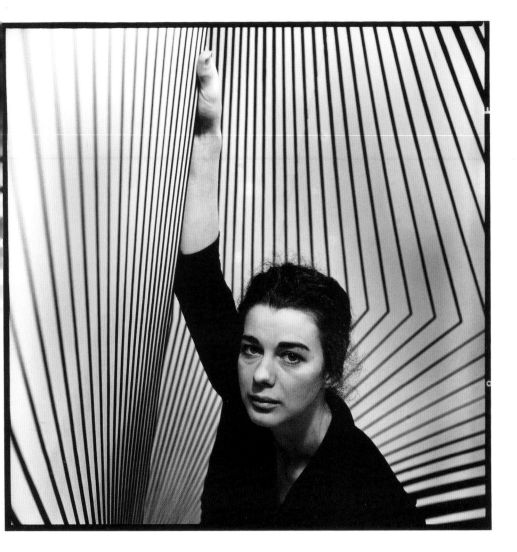

BELOW

CHRISTINE KEELER
(b.1942)
Lewis Morley, 1963

OPPOSITE

DAVID BOWIE
(1947–2016)
David Wedgbury, 1966

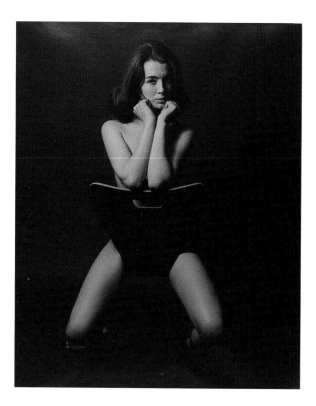

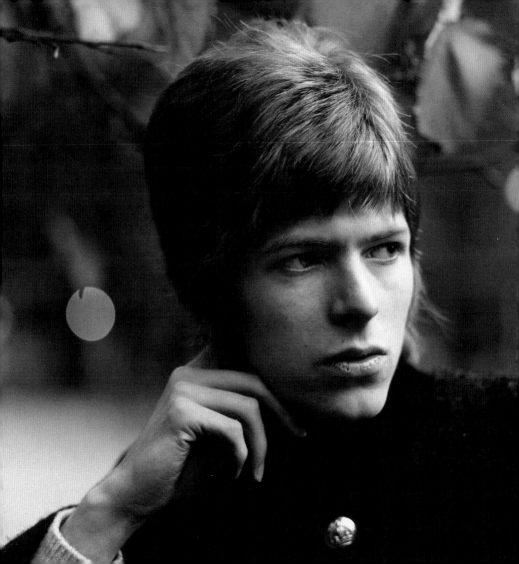

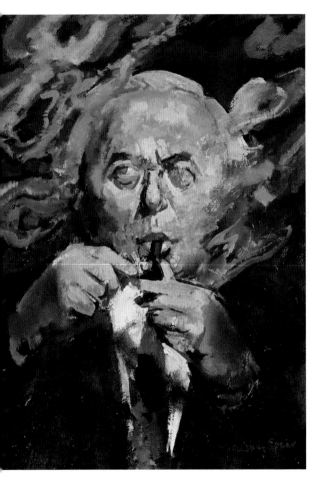

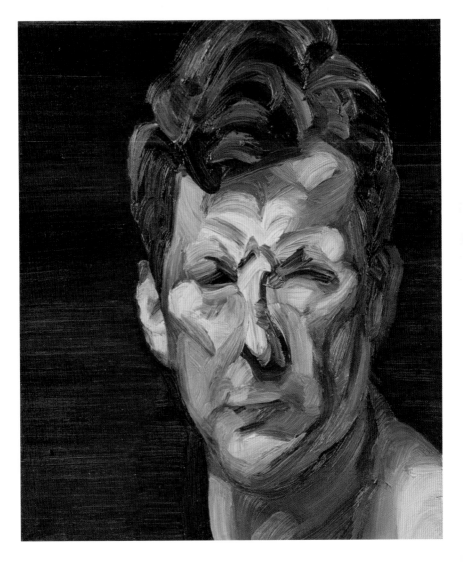

QUEEN ELIZABETH II

(b.1926)

Andy Warhol, 1985

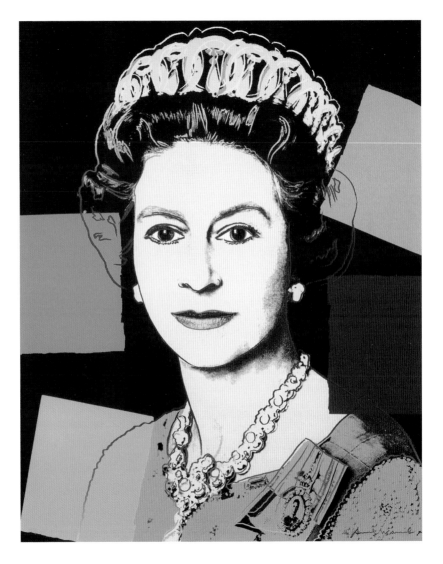

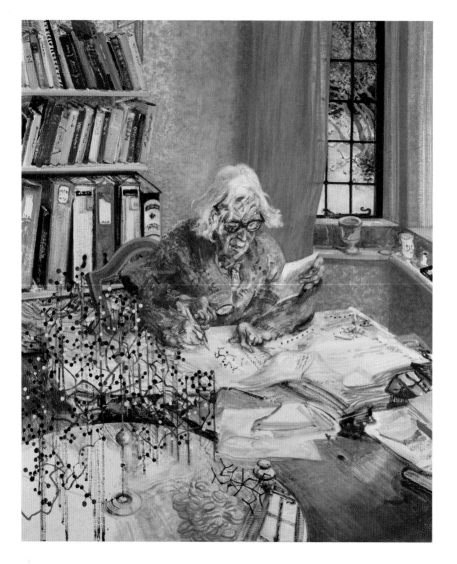

DOROTHY HODGKIN

(1910–94)

Maggi Hambling, 1985

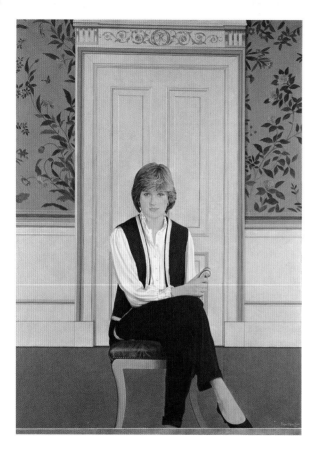

DIANA, PRINCESS
OF WALES
(1961–97)
Bryan Organ, 1981

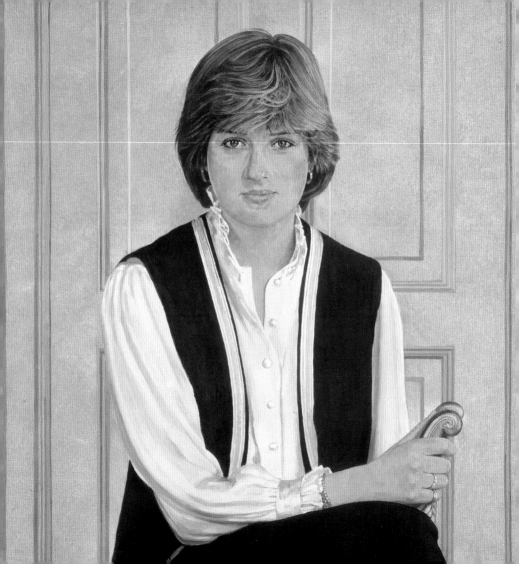

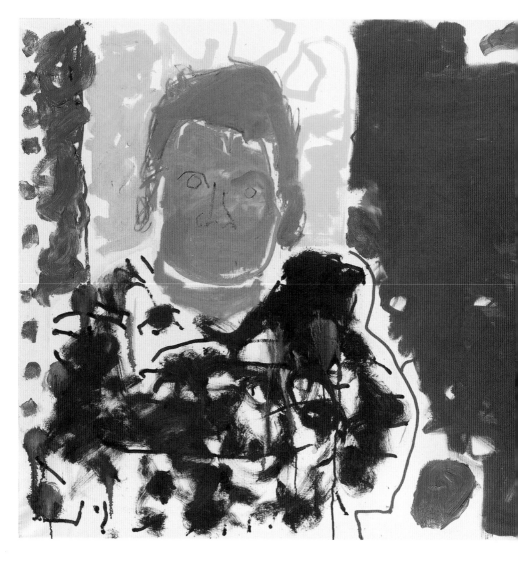

PORTRAIT OF A S BYATT:
RED, YELLOW, GREEN AND BLUE:
24 SEPTEMBER 1997
(DAME ANTONIA SUSAN ('A.S.') BYATT [b.1936])
Patrick Heron, 1997

CONTEMPORARY PORTRAITS

ALEX, BASSIST. DAMON, SINGER.
DAVE, DRUMMER. GRAHAM,
GUITARIST.
(BLUR: ALEX JAMES [b.1968],
DAMON ALBARN [b.1968],
DAVE ROWNTREE [b.1964] AND
GRAHAM COXON [b.1969])
Julian Opie, 2000

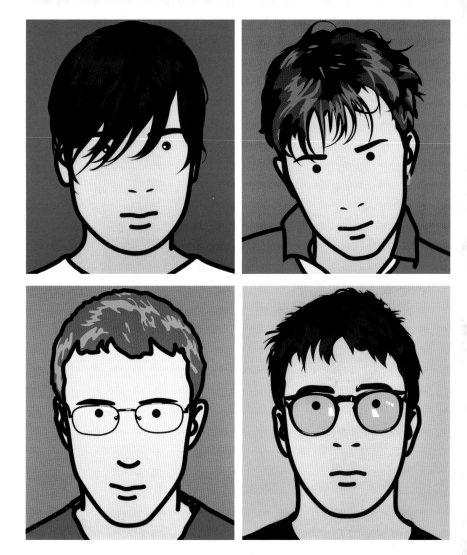

LEFT
THOMAS ADÈS
(b.1971)
Phil Hale, 2002

OPPOSITE
ALFRED BRENDEL
(b.1931)
Tony Bevan, 2005

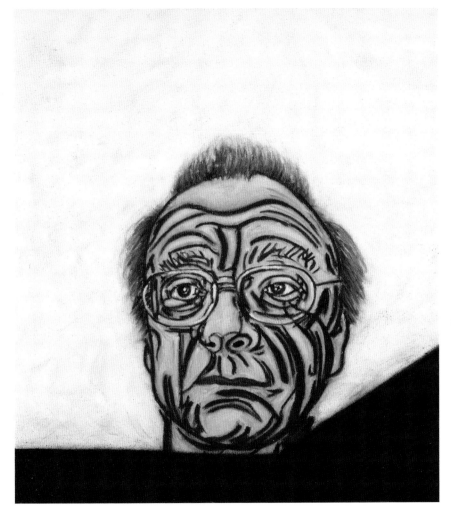

DAVID
(DAVID BECKHAM [b.1975])
Sam Taylor-Johnson
(Sam Taylor-Wood), 2004

JOANNE KATHLEEN
('J.K.') ROWLING
(b.1965)
Stuart Pearson Wright, 2005

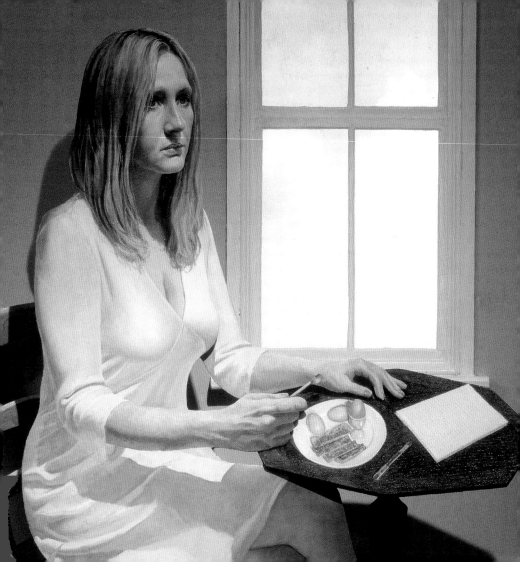

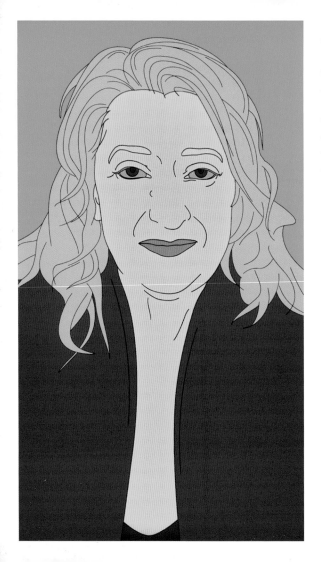

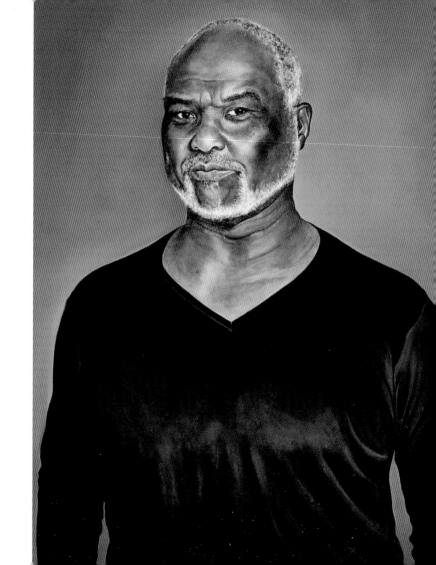

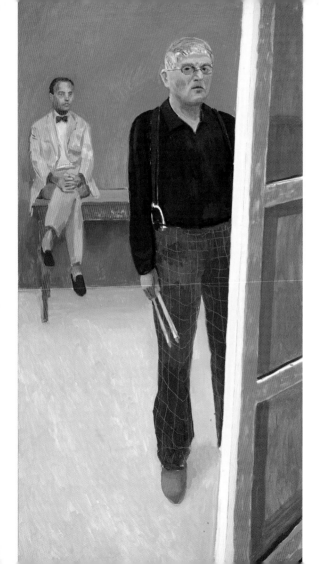

SELF-PORTRAIT WITH CHARLIE
(DAVID HOCKNEY [b. 1937])
Self-portrait, 2005

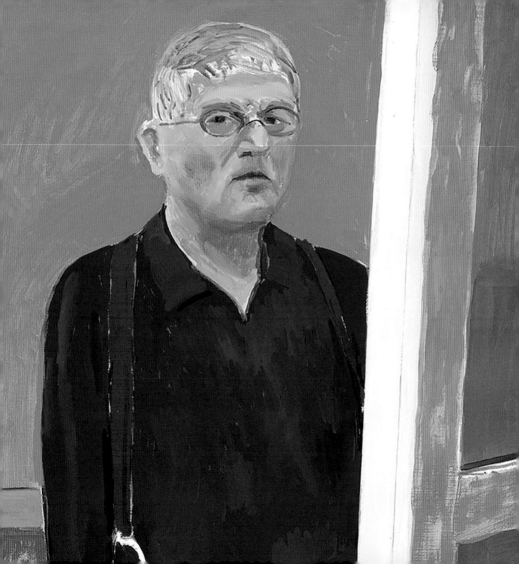

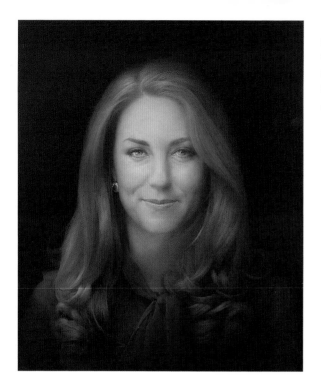

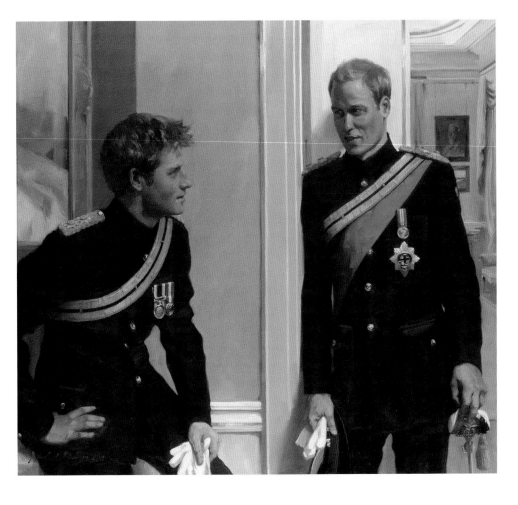

SHAMI CHAKRABARTI
(b. 1969)
Gillian Wearing, 2011

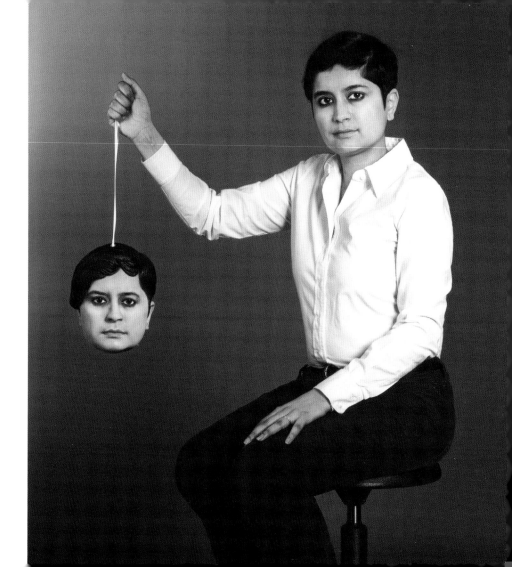

CHRONOLOGY

1856 A portrait of William Shakespeare is the Gallery's first acquisition.

1857 George Scharf appointed first Secretary (later Director).

1859 Gallery opens in Westminster with ticketed entry and receives more than 5,000 visitors.

1870 Gallery re-opens after move to South Kensington and receives more than 50,000 visitors.

1876 Visitor figure exceeds 100,000.

1885 Threat of fire leads to emergency removal of portraits to Bethnal Green.

1889 William Henry Alexander offers to fund a new building in St Martin's Place.

1895 Lionel Cust becomes Director.

1896 Gallery opens at St Martin's Place and receives more than 200,000 visitors.

1909 Charles Holmes becomes Director.

1915 Gallery closes as precaution against 'German aerial attack' during First World War.

1916 James Milner becomes Director.

RIGHT: An illustration by H.W. Brewer of the National Portrait Gallery's proposed permanent home in St Martin's Place, London, published in the *Daily Graphic*, 22 November 1893.

FAR RIGHT: 1,457 pictures were removed to the safety of outbuildings at Lord Rosebery's Buckinghamshire home, Mentmore, during the Second World War. In this photograph, frames can be seen stacked in the billiard room. Unknown photographer, 1943.

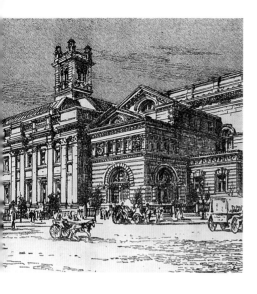

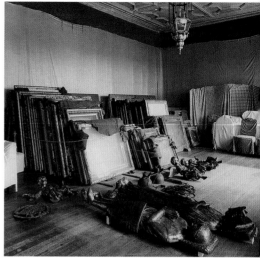

1917 National Photographic Record set up to record distinguished living men and women.

1920 Portraits re-instated after the war and Gallery re-opens.

1921 Naval Officers by Sir Arthur Cope is first of three great portrait groups acquired to memorialise the end of the war.

1927 Henry Hake becomes Director.

1932 Portrait of Mrs Beeton is first portrait photograph acquired for the Collection.

1933 Gallery's new wing, funded by Sir Joseph Duveen, opens.

1939 Gallery closes and portraits removed at outbreak of Second World War.

1945 Gallery re-opens after the war with display of newly acquired Kit-Cat Club portraits by Sir Godfrey Kneller.

1951 Charles Kingsley Adams becomes Director.

1963	*The Winter Queen: Elizabeth of Bohemia and Her Family* is first major exhibition staged by the Gallery.
1964	David Piper becomes Director.
1966	Visitor figure exceeds 250,000.
1967	Roy Strong becomes Director.
1968	*Cecil Beaton Portraits* is first photographic exhibition staged by the Gallery; George Frideric Handel by Thomas Hudson is first portrait acquired by public appeal.
1969	Rules governing acquisition of portraits changed to admit living sitters to the Collection.
1970	Portrait of Queen Elizabeth II by Pietro Annigoni unveiled; visitor figures exceed 500,000.
1974	John Hayes becomes Director.
1975	Gallery's first regional partnership opens at Montacute House, Somerset.
1979	Second regional partnership opens at Beningbrough Hall, Yorkshire.

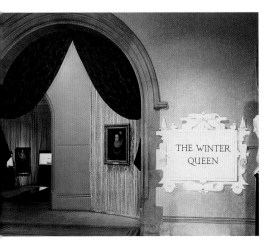

1980 Inauguration of annual Portrait Award competition, sponsored by Imperial Tobacco; commissioning programme launched with new portrait of Prince Charles by Bryan Organ.

1984 Twentieth-century galleries open.

1988 Third regional partnership opens at Bodelwyddan Castle, North Wales.

1990 BP becomes sponsor of annual Portrait Award competition.

1993 Development Plan completed with opening of Clore Education Studio and Heinz Archive & Library.

1994 Charles Saumarez Smith becomes Director; annual visitor figure exceeds 1 million.

2000 Masterplan completed and new extension, funded by Heritage Lottery Fund and major donors including Sir Christopher Ondaatje, opened by Her Majesty The Queen.

2001 Marc Quinn's DNA portrait of geneticist Sir John Sulton purchased.

2002 *Mario Testino Portraits* exhibition attracts record visitor numbers; Sandy Nairne becomes Director.

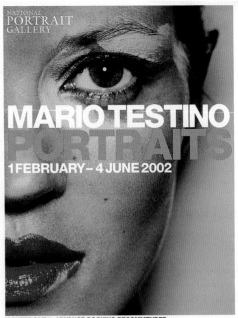

FAR LEFT: Entrance to *The Winter Queen: Elizabeth of Bohemia and Her Family* (1963). Unknown photographer, 1963.

LEFT: Sir Roy Strong (b.1935), Director of the National Portrait Gallery 1967–73. Bromide print by Godfrey Argent, 1969. NPG x32550

ABOVE: Poster for the exhibition *Mario Testino Portraits* (2002).

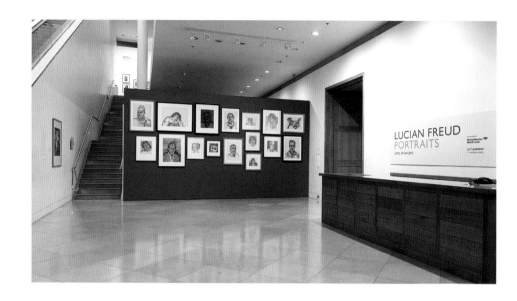

2003 Portrait of Omai by William Parry purchased jointly with Captain Cook Memorial Museum, Whitby and the National Museums & Galleries of Wales; visitor figure exceeds 1.5 million.

2006 Public appeal raises £1.6 million for acquisition of portrait of poet John Donne. As part of its 150th anniversary celebrations, the Gallery stages *David Hockney Portraits: Life Love Art*, hosts the first Portrait Gala and launches the Portrait Fund.

2007 Gallery begins ground-breaking *Making Art in Tudor Britain* research project.

2008 Gallery embarks on major programme to enhance digitisation, education and outreach with funding from the Lerner Foundation; ground-floor galleries renamed Lerner Galleries.

2012 The Duchess of Cambridge becomes the Gallery's Patron; *Lucian Freud Portraits* exhibition achieves record attendance and visitor figure exceeds 2 million.

2014 Van Dyck self-portrait acquired by public appeal and with support from Heritage Lottery Fund, the Art Fund, the Portrait Fund, the Monument Trust, the Garfield Weston Foundation and several major individual supporters.

2015 Nicholas Cullinan becomes Director.

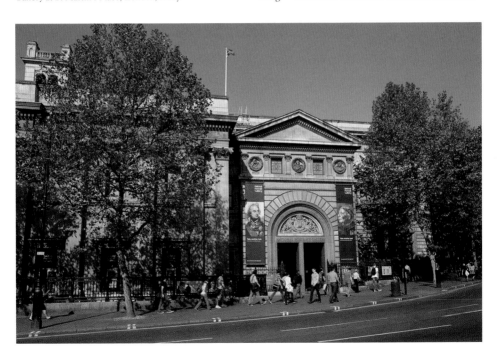

KING RICHARD III
Unknown English artist, late 16th century, after a portrait of the 15th century
Oil on panel, 638 x 470mm • NPG 148
Richard III (1452–85), the last king of England from the House of York, ruled from 1483 until his death at the Battle of Bosworth Field two years later. This portrait was made more than 100 years after Richard's death, the likeness probably copied from an original drawing or painting (now lost).

MIKE'S BROTHER (SIR PAUL McCARTNEY)
Sam Walsh, 1964
Oil on masonite, 1825 x 1550mm • NPG 6172
As a member of The Beatles, Paul McCartney was an international star by 1964 and one of the most recognisable faces in popular culture. Following the group's formation in Liverpool in 1960, the success of their debut single 'Love Me Do' attracted a mass following in Britain and 'Beatlemania' soon spread to the United States. The title of this portrait, painted by Liverpool-based Sam Walsh (1934–89) at the height of the group's fame, refers ironically to McCartney's less-well-known brother, Mike McGear, who was a friend of the artist and achieved success in the 1960s as part of the satirical trio The Scaffold.

WILLIAM SHAKESPEARE
Attributed to 'Taylor', *c.*1600–10
Oil on canvas, feigned oval, 552 x 438mm • NPG 1
The poet, actor and playwright William Shakespeare (1564–1616) is one of the world's most celebrated cultural figures, and it is perhaps appropriate that this painting was the first to be presented

to the newly founded National Portrait Gallery in 1856. The work is known today as the 'Chandos' portrait after a previous owner.

TUDOR PORTRAITS

KING HENRY VII
Unknown Flemish artist, dated 1505
Oil on panel, 425 x 305mm • NPG 416
The earliest painting in the National Portrait Gallery's Collection is this portrait of Henry VII (1457–1509), head of the House of Lancaster (signified here by the red rose). His victory over Richard III at the Battle of Bosworth Field in 1485 marked the start of the Tudor monarchy.

KING HENRY VII AND KING HENRY VIII
Hans Holbein the Younger, *c.*1536–7
Black chalk, ink and watercolour on paper, laid on canvas, 2578 x 1372mm • NPG 4027
This large work is the preparatory drawing, or cartoon, for the left-hand section of a great wall painting commissioned for the Privy Chamber at Whitehall. It shows King Henry VIII (1491–1547) on the left with his father Henry VII (1457–1509), the founder of the dynasty. Holbein's painting was destroyed in the Whitehall Palace fire of 1698.

THOMAS CROMWELL, EARL OF ESSEX
After Hans Holbein the Younger, early 17th century after a portrait of *c.*1532–3
Oil on panel, 781 x 619mm • NPG 1727
A brilliant administrator and legal and evangelical reformer, the statesman Thomas Cromwell (b. in or before 1485–1540) rose to power as the right-hand man of Cardinal Wolsey. He was the principal architect of the annulment

of Henry VIII's marriage to Katherine of Aragon and the subsequent break with Rome. Cromwell sat to Holbein the Younger (1497/8–1543) after becoming Master of the Jewels in 1532.

ANNE BOLEYN
Unknown artist, late 16th century after a portrait of c.1533–6
Oil on panel, 543 x 416mm • NPG 668
Anne Boleyn (c.1500–36) was the second consort of Henry VIII. They married in secret in 1533, shortly before the King's marriage to Katherine of Aragon was annulled. Later that year their daughter, the future Elizabeth I, was born. In 1536 Anne was charged with adultery and incest and executed for treason.

KATHERINE PARR
Attributed to Master John, c.1545
Oil on panel, 1803 x 940mm • NPG 4451
Katherine Parr (1512–48) was the sixth and last wife of King Henry VIII, whom she married in 1543. She was particularly interested in the medium of portraiture, and all Henry's children were painted during Katherine's time as queen.

KING EDWARD VI
Unknown English artist, c.1547
Oil on panel, 1556 x 813mm • NPG 5511
Edward VI (1537–53) ascended to the throne in January 1547, aged nine years, around the time this portrait was painted. His pose is similar to that of his father Henry VIII (page 14). Technical analysis has revealed that his feet were originally even further apart and were adjusted by the artist before the portrait was finished.

QUEEN MARY I
Hans Eworth, signed in monogram and dated 1554
Oil on panel, 216 x 169mm • NPG 4861

Mary I (1516–58), England's last Roman Catholic monarch, succeeded her devoutly Protestant half-brother Edward IV in 1553, following a brief nine days' reign by Lady Jane Grey (1537–54). This portrait was painted in 1554, the year of Mary's marriage to King Philip II of Spain – an alliance that was linked in the public's mind with the reinstatement of Catholicism.

QUEEN ELIZABETH I
Unknown Continental artist, c.1575
Oil on panel, 1130 x 787mm • NPG 2082
This portrait of Elizabeth I (1533–1603), the last Tudor monarch, shows a confident ruler and would have been produced following a direct sitting from the life. The resulting pattern was used for the remainder of the Queen's reign, suggesting she approved the likeness. It is known today as the 'Darnley' portrait after a subsequent owner.

SIR WALTER RALEGH
Unknown English artist, dated 1588
Oil on panel, 914 x 746mm • NPG 7
A true 'Renaissance man', Walter Ralegh (1554–1618) was a poet, explorer and soldier as well as being a favourite of Elizabeth I. (This portrait is a visual statement of his devotion to her.) He organised and financed a number of expeditions to North America, and later in life made several unsuccessful attempts to find gold in South America.

MARY STEWART, QUEEN OF SCOTS
After Nicholas Hilliard, late 16th century
Oil on panel, 791 x 902mm • NPG 429
The daughter of James V of Scotland and Mary of Guise, Mary Stewart (1542–87) was brought up in France as a Roman Catholic. She married the

dauphin, subsequently Francis II of France, in 1558 but following his early death returned to Scotland, ruling for seven turbulent years. As heir to the English throne, Mary became the focus of Roman Catholic rebellion. In 1586 she was declared guilty of treason and was executed the following year.

STUART PORTRAITS

BEN JONSON
Abraham van Blyenberch, c.1617
Oil on canvas, 470 x 419mm • NPG 2752
One of the most successful playwrights and poets of the seventeenth century, Ben Jonson (1573?–1637) was probably more famous and celebrated during his lifetime than his contemporary William Shakespeare. Jonson was one of a small group of people painted by the Flemish artist Abraham van Blyenberch (1575/6–1624) during his visit to England between 1617 and 1621.

ELIZABETH OF BOHEMIA
Robert Peake the Elder, c.1610
Oil on canvas, 1713 x 968mm
• NPG 6113
Elizabeth of Bohemia (1596–1662), named after her godmother Elizabeth I, was the daughter of James VI of Scotland and I of England. This portrait by the English artist Robert Peake (c.1551–1619) advertises the young princess's wealth, beauty and status using a pose associated from the early sixteenth century with potential royal brides.

KING CHARLES I
Daniel Mytens, 1631
Oil on canvas, 2159 x 1346mm
• NPG 1246
The unshakeable belief that Charles I (1600–49) had in the 'Divine Right of

Kings' made him an inflexible ruler after he acceded to the throne in 1625. He dismissed Parliament in 1629 and ruled alone for eleven years. His imposition of taxes and attempts to impose religious uniformity led eventually to civil war. He was defeated, and was executed in Whitehall on 30 January 1649.

SIR ANTHONY VAN DYCK
Self-portrait, c.1640
Oil on canvas, 5970 x 4730mm
• NPG 6179
Sir Anthony van Dyck (1599–1641) was arguably the most influential portrait painter ever to work in this country. He turned British portraiture away from the stiff, intricately detailed, formal approach of Tudor and Jacobean painting, developing a distinctive fluid, shimmering style that was to dominate portraiture in Britain for the following three centuries. Flemish by birth, he was knighted by Charles I on his arrival in England and appointed Principal Painter to the King.

SAMUEL PEPYS
John Hayls, 1666
Oil on canvas, 756 x 629mm • NPG 211
The naval administrator Samuel Pepys (1633–1703) is best known for his Diary, an extraordinary record of his life in Restoration London. On 17 March 1666 Pepys wrote of sitting for this portrait: 'I sit to have it full of shadows and do almost break my neck looking over my shoulders to make the posture firm for him to work by.' His gown was hired especially for this portrait, and the music he holds is his own composition.

OLIVER CROMWELL
Robert Walker, c.1649
Oil on canvas, 1257 x 1016mm • NPG 536

Oliver Cromwell (1599–1658) rose from the position of a country gentleman to become a leading statesman, soldier and finally head of state as Lord Protector (1653–8). As the country descended into civil war, he emerged as a natural leader, taking charge of the New Model Army in brutal campaigns in Ireland and Scotland following the execution of Charles I in 1649. Cromwell refused the crown in 1657, and his death left a power vacuum that would only be filled by the restoration of the monarchy in 1660.

MARY BEALE
Self-portrait, c.1665
Oil on canvas, 1092 x 876mm
• NPG 1687
Mary Beale (1633–99) is a very rare example of a seventeenth-century woman who became a professional artist. Her husband Charles's job was insecure and, after a period supplementing the family income by painting mainly for friends, she set up in professional practice with Charles as her studio manager. The records he kept are an important source of information about seventeenth-century studio practice.

KING CHARLES II
Attributed to Thomas Hawker, c.1680
Oil on canvas, 2267 x 1356mm
• NPG 4691
Charles II (1630–85), who ascended to the throne at the age of 30 in 1660, after the failure of the Commonwealth, has always divided opinion. He is remembered for his numerous mistresses and illegitimate children and his secret treaty with France, but also for his interest in and support for the development of science and technology, and his popularity and ease with ordinary people.

NELL GWYN
Simon Verelst, c.1680
Oil on canvas, 737 x 632mm • NPG 2496
Nell Gwyn (1651?–87) was one of the first women to act on the public stage, having apparently worked first as an orange-seller outside the theatre. As a mistress of Charles II, she became perhaps the most famous name of the Restoration court, bearing two sons by the King. He bought her a house in Pall Mall, paid her a pension and is said to have remembered her on his deathbed with the words 'Let not poor Nelly starve'.

SIR ISAAC NEWTON
Sir Godfrey Kneller, 1702
Oil on canvas, 756 x 622mm • NPG 2881
One of the greatest of all scientists and thinkers, Isaac Newton (1642–1727) was the most important influence on theoretical physics and astronomy before Einstein. His most significant contribution to scientific thought is the theory of universal gravitation, the idea for which supposedly first came to him when he saw an apple falling from a tree.

HENRY PURCELL
John Closterman, c.1695
Black chalk heightened with white, 381 x 286mm • NPG 4994
Henry Purcell (1659–95) was the pre-eminent composer of the Restoration period and is celebrated as the father of modern music in England. This chalk drawing by the German artist John Closterman (1660–1711) was probably made in the final year of Purcell's life. It is Closterman's only known portrait sketch, and the earliest surviving drawing of an English composer.

SIR CHRISTOPHER WREN
Sir Godfrey Kneller, 1711
Oil on canvas, 1245 x 1003mm
• NPG 113
Christopher Wren (1632–1723) first came to prominence as an astronomer and mathematician, but his career changed dramatically with the Great Fire of London in 1666, after which he devoted himself to architecture. He was commissioned to rebuild dozens of City churches destroyed by the fire. This portrait celebrates the completion of his masterpiece, St Paul's Cathedral, in 1711.

GEORGIAN PORTRAITS

SIR JOSHUA REYNOLDS
Self-portrait, c.1747–9
Oil on canvas, 635 x 743mm • NPG 41
Joshua Reynolds (1723–92) was the leading portrait painter in eighteenth-century Britain and the first President of the Royal Academy of Arts. This early portrait is unique in depicting him at work, clothes loosened and displaying the tools of his trade: a canvas, palette and brushes. It conveys the artist's confidence in his talents and ambitions for the future.

WILLIAM HOGARTH
Self-portrait, 1758
Oil on canvas, 451 x 425mm • NPG 289
William Hogarth (1697–1764), renowned for his satirical paintings and engravings, was also a talented and sensitive portraitist. This informal self-portrait shows him painting Thalia, the classical Muse of Comedy. X-rays reveal that the picture originally contained a nude model instead of his easel, and the painter's dog urinating on a pile of Old Master paintings.

EMMA, LADY HAMILTON
George Romney, c.1785
Oil on canvas, 737 x 597mm • NPG 294
Emma, Lady Hamilton (c.1765–1815), is most famous as the muse of artist George Romney (1734–1802) and as Lord Nelson's lover. Born Emma Lyon, she rose through society as the mistress of a string of older men, eventually marrying Sir William Hamilton, British Ambassador to Naples. Her affair with Nelson, begun while he was convalescing in Naples after the Battle of the Nile, was an international scandal. On his death, he entrusted Emma's care to the nation but his wish was ignored and she died penniless in France.

THOMAS GAINSBOROUGH
Self-portrait, c.1758–9
Oil on canvas, 762 x 635mm • NPG 4446
Thomas Gainsborough (1727–88) was, with Joshua Reynolds, the leading portrait painter in eighteenth- century Britain. Nevertheless, he felt trapped by his profession and preferred to paint landscapes: 'If the People with their damn'd Faces could but let me alone a little', he recorded in a letter of 25 May 1768 to his friend James Unwin. This early self-portrait was painted shortly before he moved to Bath, where he established a fashionable studio in 1759.

GEORGE FRIDERIC HANDEL
Thomas Hudson, signed T. Hudson Pinxt and dated 1756
Oil on canvas, 2388 x 1461mm
• NPG 3970
Born in Saxony, the composer George Frideric Handel (1685–1759) worked across Europe before settling in London, finally becoming a British citizen in 1727. His orchestral scores include *Water Music* (1717) and *Music for the Royal Fireworks*

(1749), and the score of his most famous oratorio, *Messiah* (1741), is depicted on the table in this portrait.

CHARLES GENEVIÈVE LOUIS AUGUSTE ANDRÉ TIMOTHÉE D'EON DE BEAUMONT (CHEVALIER D'EON)
Thomas Stewart, after Jean-Laurent Mosnier, signed and dated 1792
Oil on canvas, 765 x 640mm • NPG 6937
The Chevalier d'Eon (1728–1810), a minor French aristocrat, had a triumphant career as a French diplomat, soldier and spy before publicly assuming a female gender. D'Eon first came to London in 1763 to negotiate peace at the end of the Seven Years' War, after which he was ordered to return to France but refused to go. Instead, he blackmailed the French court with his knowledge of secret invasion plans against England and published confidential diplomatic correspondence that implicated prominent French ministers in corruption. Rumours that d'Eon was a woman in disguise spread from 1771 onwards and were widely accepted. In 1777, after a period of exile from France, Louis XVI offered d'Eon a royal pension if he henceforth exclusively wore women's clothing. In 1785 d'Eon returned to England, where he moved in high society and became a female fencer.

SARAH SIDDONS
Sir William Beechey, 1793
Oil on canvas, 2456 x 1537mm
• NPG 5159
Sarah Siddons (1755–1831), one of the greatest actresses in the history of English theatre, was born into the Kemble family, a powerful dynasty of actors. She showed talent early and after establishing her reputation around the

country made her London debut in 1782, playing the title role in David Garrick's *Isabella, or the Fatal Marriage* (1808) at Drury Lane. She went on to dominate the London stage for three decades.

JOHN CONSTABLE
Ramsay Richard Reinagle, c.1799
Oil on canvas, 762 x 638mm • NPG 1786
Although not recognised as such in his lifetime, John Constable (1776–1837) is one of England's greatest and most original landscape painters. At a time when domestic landscape was valued less than classical views, he focused on the English countryside and particularly his native Suffolk. This portrait was probably painted when Ramsay Richard Reinagle (1775–1862), who had been a fellow student at the Royal Academy, stayed with Constable in Suffolk during 1799.

MARY WOLLSTONECRAFT
John Opie, c.1797
Oil on canvas, 768 x 641mm • NPG 1237
A political radical, Mary Wollstonecraft (1759–97) is one of the founders of modern feminism. Her most famous work, *A Vindication of the Rights of Woman* (1792), made a powerful case for the liberation and education of women. This portrait by John Opie (1761–1807) was probably painted around the time of her marriage to the philosopher William Godwin, with whom she had a daughter, the author of *Frankenstein*, Mary Shelley.

HORATIO NELSON, VISCOUNT NELSON
Sir William Beechey, 1800
Oil on canvas, 623 x 483mm • NPG 5798
Admiral Lord Nelson (1758–1805) remains one of Britain's most illustrious war heroes. In 1793, following the outbreak of war with France, he lost an

eye in a successful attack on Corsica, and his right arm in a battle of 1797. A masterful tactician, he led the British fleet to several famous victories before destroying Napoleon's sea power at the Battle of Trafalgar (1805), where he was mortally wounded. This vivid sketch by William Beechey (1753–1839) is a study for a full-length portrait.

GEORGE GORDON BYRON, 6TH BARON BYRON
Thomas Phillips, 1835
Oil on canvas, 765 x 639mm • NPG 142
Famously deemed 'mad, bad and dangerous to know' by Lady Caroline Lamb, the flamboyant Lord Byron (1788–1824) was the most painted poet of his generation. With his brooding good looks, charisma and notoriously wild lifestyle, he constructed himself as the ultimate English Romantic hero. This theatrical portrait by Thomas Phillips (1770–1845), a copy from the artist's full-length of 1813, shows the 'popular poet of the East' depicted in luxurious Albanian costume.

WILLIAM BLAKE
Thomas Phillips, 1807
Oil on canvas, 921 x 720mm • NPG 212
William Blake (1757–1827), visionary poet, painter and engraver, claimed he had grown up 'conversing with angels' and lived according to his own mystical and moral beliefs. In his illuminated 'prophetic book', *Songs of Innocence and of Experience* (1794), he developed the technique of relief etching, uniting both word and image on a single plate. This portrait by Thomas Phillips (1770–1845) depicts Blake in a moment of reverie.

JANE AUSTEN
Cassandra Austen, c.1810
Pencil and watercolour, 114 x 80mm • NPG 3630
This is the only certain portrait from life of Jane Austen (1775–1817), one of Britain's greatest and best-loved novelists. It was made by her sister Cassandra (1773–1845), her closest confidante. Austen's novels *Sense and Sensibility* (1811), *Pride and Prejudice* (1813), *Mansfield Park* (1814), *Emma* (1815) and the posthumously published *Northanger Abbey* (1818) and *Persuasion* (1818) are among the most widely read books in the English language.

JOHN KEATS
Joseph Severn, dated 1821–3
Oil on canvas, 565 x 419mm • NPG 58
The best-known poems of John Keats (1795–1821), including 'To Autumn' and 'La Belle Dame sans Merci', were inspired by a walking tour of the Lake District and Scotland in 1818. They were published a year before he died at the age of twenty-five from consumption in Rome, in the arms of Joseph Severn (1793–1879). In this posthumous portrait, one of several by Severn, the artist has imagined his friend at home in Hampstead on the morning he wrote his famous meditation on mortality, 'Ode to the Nightingale' (1819).

PERCY BYSSHE SHELLEY
Amelia Curran, 1819
Oil on canvas, 597 x 476mm • NPG 1234
Percy Bysshe Shelley (1792–1822) was among the most radical of the English Romantic Poets. An atheist, his first major poem, 'Queen Mab' (1813), denounced meat-eating and marriage. Yet Shelley married twice, the second time to Mary Wollstonecraft Godwin.

In 1818, the couple travelled to Italy, where Shelley produced some of his best work before drowning in a storm off the coast at La Spezia. Painted in Rome a few years earlier, this portrait by the art student Amelia Curran (1775–1847) is the only authentic likeness of the poet.

WILLIAM WILBERFORCE
Sir Thomas Lawrence, 1828
Oil on canvas, 965 x 1092mm • NPG 3
The Tory Member of Parliament William Wilberforce (1759–1833) devoted his career to social reform and campaigned for twenty years to end the slave trade. Wilberforce's Bill was eventually passed in 1807, after which he campaigned for the total abolition of slavery, dying one month before the Slavery Abolition Act was passed in 1833. This portrait by Thomas Lawrence (1769–1830) was the result of a single sitting in 1825, when Wilberforce was suffering from extreme skeletal degeneration, which helps to explain the awkward pose and unfinished state of this painting.

IRA ALDRIDGE
After James Northcote, c.1826
Oil on canvas, 763 x 632mm • Lent by a private collection, 2012 • NPG L251
Ira Aldridge (1807–67) was the first major black actor on the British stage. He arrived from America in 1824 and first appeared in London in 1825 playing the part of Orinokoo in *The Revolt of Surinam*, or, a *Slave's Revenge* at the Royal Coburg Theatre (now the Old Vic). This portrait depicts him as Othello in Manchester, a role he reprised in his West End debut in 1833. After several Continental tours in the 1850s and 1860s, he developed a significant following in Europe and died in Poland.

VICTORIAN AND EDWARDIAN PORTRAITS

SIR JOHN HERSCHEL
J.J.E. Mayall, c.1848
Daguerreotype, 86 x 70mm • NPG P660
This portrait of the great astronomer and physicist John Herschel (1792–1871), pictured adopting a 'thinking man's pose', is especially relevant in that the sitter himself made contributions to early photography and originated the terms 'photograph', 'negative' and 'positive'. The photographer John Jabez Edwin Mayall (1813–1901) opened a daguerreotype studio in Philadelphia in the early 1840s before moving to Britain, where he set up his own studio in London in 1851.

THE BRONTË SISTERS (ANNE, EMILY, CHARLOTTE)
Branwell Brontë, c.1834
Oil on canvas, 902 x 746mm • NPG 1725
The novels of the Brontë sisters defied nineteenth-century literary taste. This sole surviving group portrait of the sisters (left to right: Anne (1820–49), Emily (1818–48) and Charlotte (1816–55)) was discovered folded up on top of a cupboard by Charlotte's husband, the Reverend A.B. Nicholls, in 1914. The barely discernible male figure in the middle, previously concealed by a painted pillar, is almost certainly a self-portrait of the artist, the sisters' dissolute brother Branwell (1817–48).

CHARLES DICKENS
Daniel Maclise, signed and dated 1839
Oil on canvas, 914 x 714mm • NPG 1172
Charles Dickens (1812–70), author of *Oliver Twist* (1837–9), *A Christmas Carol*

(1843), *Bleak House* (1852–3) and *Great Expectations* (1860–1), was one of the greatest novelists of his age. This portrait was painted by his friend Daniel Maclise (1806–70) in 1839, the year *Nicholas Nickleby* was published. In a letter dated 28 June, Dickens wrote: 'Maclise has made another face of me, which all people say is astonishing.'

ISABELLA BEETON
Maull & Polyblank, 1857
Hand-tinted albumen print, 184 x 149mm • NPG P3
Aimed at the aspiring middle classes and best known today for its recipes, *Beeton's Book of Household Management* (1861) was an essential guide to running all aspects of a Victorian household. Isabella Beeton (1836–65) was encouraged in her pursuit of an authorial career by her husband, a successful publisher. Her famous book became an immediate hit, selling 60,000 copies in its first year of publication. It has never been out of print.

ISAMBARD KINGDOM BRUNEL
Robert Howlett, 1857
Albumen print, 286 x 225mm • NPG P112
This photograph of Isambard Kingdom Brunel (1806–59) by Robert Howlett (d.1858) has become an enduring image of Victorian engineering might. It is one of a series that shows the most famous civil engineer of his generation at one of the attempted launches of the SS *Great Eastern*. Built on London's Isle of Dogs, she was the last of the great ocean-going ships that Brunel designed, and by far the largest vessel of her time.

THE SECRET OF ENGLAND'S GREATNESS (QUEEN VICTORIA PRESENTING A BIBLE IN THE AUDIENCE CHAMBER AT WINDSOR)

Thomas Jones Barker, c.1863
Oil on canvas, 1676 x 2138mm
• NPG 4969

This imagined scene, showing Queen Victoria (1819–1901) receiving an ambassador from East Africa, is based upon a popular, but unfounded, anecdote. When asked by a foreign delegation how Britain had become so powerful in the world, Victoria supposedly replied that it was not because of its military or economic might. Handing him a copy of the Bible, she said, 'Tell the Prince that this is the Secret of England's Greatness'. In the painting she is attended by Prince Albert (1819–61), the foreign secretary Lord John Russell (1792–1878) and the prime minister Lord Palmerston (1784–1865).

ALFRED TENNYSON, 1ST BARON TENNYSON

Julia Margaret Cameron, 1865
Albumen print, 249 x 201mm
• NPG x18023

Alfred Tennyson (1809–92) was the most popular poet of the Victorian age. Julia Margaret Cameron (1815–79) was a close friend and neighbour on the Isle of Wight, and photographed him often. Cameron took up photography in her late forties and was one of the first, and remains one of the greatest, portrait photographers. This image, which Tennyson referred to as 'the Dirty Monk', illustrates Cameron's mid-Victorian fascination with High Renaissance art and the Romantic medievalism of the Pre-Raphaelites.

CHOOSING (ELLEN TERRY)

George Frederic Watts, 1864
Oil on panel, 480 x 352mm • NPG 5048

The great English actress Ellen Terry (1847–1928) played many leading roles in Henry Irving's productions. This portrait was painted by George Frederic Watts (1817–1904) at the time of his marriage to Terry (he was forty-five, she not quite seventeen). This work is at once a portrait and an allegory: Terry must choose between the spectacular yet scentless camellias (symbolising innocence) and the sweet-smelling violets (signifying worldly vanities – such as the stage) cradled in her left hand.

HENRY FAWCETT AND DAME MILLICENT GARRETT FAWCETT

Ford Madox Brown, 1872
Oil on canvas, 1086 x 838mm
• NPG 1603

This portrait by Ford Madox Brown (1821–93) shows two of the period's leading liberal intellectuals. Henry Fawcett (1833–84), Professor of Political Economy at Cambridge University and a Member of Parliament, was an advocate of radical causes and a keen supporter of feminism. Blinded by a shooting accident in 1858, he resolved that this would not affect how he spent his life and career. He is shown with his wife, Millicent Garrett Fawcett (1847–1929), a leading feminist who in 1897 became president of the influential National Union of Women's Suffrage Societies.

WILLIAM MORRIS

George Frederic Watts, 1870
Oil on canvas, 648 x 521mm • NPG 1078

William Morris (1834–96) was one of the most influential artistic figures of the Victorian period. His name has become synonymous with the Arts and Crafts movement, which embraced standards of medieval craftsmanship in order to oppose factory mass-production. His busy industry and apparent dislike of portraiture made him an elusive subject. According to Mary Seton Watts, wife of the artist George Frederic Watts (1817–1904), there may have been just one sitting for the picture, on 15 April 1870.

MARY SEACOLE

Albert Charles Challen, 1869
Oil on panel, 240 x 180mm • NPG 6856

Jamaican-born Mary Seacole (1805–81) learnt her nursing skills from her mother, who ran a boarding house for invalid soldiers. In 1854 she sailed for England to volunteer for service as a nurse in the Crimean War (1853–6), but was refused by the War Office. Undeterred, Seacole travelled to the region at her own expense, caring for sick and wounded troops at Balaklava. This small portrait by the London artist Albert Charles Challen (1847–81), which came to light in 2002, is the only known painting in oil of Seacole.

CHARLES DARWIN

John Collier, 1883
Oil on canvas, 1257 x 965mm • NPG 1024

His five-year voyage on the *Beagle* took the naturalist Charles Darwin (1809–82) to some of the world's most remote places, including South America, the Galapagos, Australia and South Africa. The samples Darwin collected on this expedition provided the foundations of his work on evolution, *On the Origin of Species by Means of Natural Selection* (1859). This portrait of Darwin in old age was painted by John Collier (1850–1934), son-in-law of Thomas Huxley, Darwin's defender in the furore surrounding the publication of his work.

SAMUEL COLERIDGE-TAYLOR
Walter Wallis, 1881
Oil on canvas, 256 x 205mm • NPG 5724
Samuel Coleridge-Taylor (1875–1912)
was the son of a doctor from Sierra
Leone and an English mother. Brought
up in Croydon, as a child he sat for
painters associated with the Croydon Art
Club – and this is one of the resulting
portraits, by Walter Wallis, principal of
Croydon Art School. In 1890 Coleridge-
Taylor entered the Royal College of
Music to study violin and composition.
A composer of opera, orchestral, church
and chamber music, his best-known
work, the cantata trilogy 'The Song of
Hiawatha' (1898–1900), was first played
in public when he was still a student.

OSCAR WILDE
Napoleon Sarony, 1882
Albumen panel card, 305 x 184mm
• NPG P24
Poet, playwright, legendary wit and gay
icon, Oscar Wilde (1854–1900) is one
of the best-known figures of the late
nineteenth century. This photograph
of Wilde, taken in New York while on
a lecture tour to promote Aestheticism
in America, captures him before
such literary triumphs as the play *The
Importance of Being Earnest* (1895) and
The Picture of Dorian Gray (1891), his
only novel. Wilde's success was cut short
by his trial and imprisonment for gross
indecency. His reputation destroyed,
he died in poverty in France.

HENRY JAMES
John Singer Sargent, signed and
dated 1913
Oil on canvas, 851 x 673mm • NPG 1767
The American-born novelist Henry
James (1843–1916) is especially
remembered for his novels that explore
the conflict between American and
European attitudes, such as *Washington
Square* (1880), *The Portrait of a Lady*
(1881) and *The Golden Bowl* (1904).
Painter and playwright Walford
Graham Robertson, who knew them
both, described John Singer Sargent
(1856–1925) and Henry James as true
friends: 'They understood each other
perfectly and their points of view were in
many ways identical'.

EDWARD CARPENTER
Roger Fry, 1894
Oil on canvas, 749 x 438mm • NPG 2447
Socialist writer and campaigner
for homosexual equality, Edward
Carpenter (1844–1929) was one of the
great dissenters from contemporary
orthodoxies. After a brief career at
Cambridge University, he settled in
Millthorpe, Derbyshire, where he
combined his literary work with the
simple life and, after 1893, lived openly
with his lover, George Merrill. Roger Fry
(1866–1934), a champion of avant-garde
art and the painter of this portrait, was
an undergraduate at Cambridge when he
first met Carpenter, who was lecturing
there, in 1886.

WILLIAM GILBERT ('W.G.') GRACE
Attributed to Archibald Wortley, 1890
Oil on canvas, 902 x 699mm • NPG 2112
W.G. Grace (1848–1915) was one of the
great celebrities of the later Victorian
period, and his cricketing triumphs
earned him a special place in national
life. He made his debut at Lord's and the
Oval in the summer of 1864 and scored
his first century in the same year. In an
extraordinary career in first-class cricket
between 1865 and 1908, he scored 54,896
runs, averaging 39.55, and took 2,876
wickets (average 17.92).

GWEN JOHN
Self-portrait, *c.*1900
Oil on canvas, 610 x 378mm • NPG 4439
The commanding gaze of Gwen John
(1876–1939) in this self-portrait reflects
the passionate determination with which
she forged her artistic career. She studied
at the Slade School of Fine Art and at
Whistler's Académie Carmen in Paris.
In London, she exhibited at the New
English Art Club. In 1904 she moved
to Paris, working initially as an artists'
model (including for Rodin, with whom
she had a passionate relationship), before
becoming an established artist.

ROBERT LOUIS STEVENSON
Sir William Blake Richmond, 1886
Oil on canvas 737 x 559mm • NPG 1028
Robert Louis Stevenson (1850–94)
abandoned engineering and the law
early in life and turned to writing. His
name will forever be associated with
Treasure Island (1883), but he also wrote
other classics of the language such as *The
Strange Case of Dr Jekyll and Mr Hyde* and
Kidnapped (both 1886), published around
the time this portrait by William Blake
Richmond (1842–1921) was painted – in
one sitting, on a hot August afternoon at
the artist's home in Hammersmith.

ROBERT FALCON SCOTT
Herbert Ponting, 1911
Carbon print, 356 x 457mm • NPG P23
Captain Scott (1868–1912) invited
Herbert Ponting (1870–1935) to record
his final, tragic expedition to reach
the Antarctic. Working in extremely
hazardous conditions, Ponting achieved
photographs of exceptional technical
and aesthetic quality before ill health
forced him to return home early. This
example shows Scott in his hut at Cape
Evans on 7 October 1911. On 17 January

1912 he reached the South Pole, only to find that the Norwegian explorer Roald Amundsen had arrived a month earlier. Scott and his companions perished on the return journey.

TWENTIETH-CENTURY PORTRAITS

RUPERT BROOKE
Sherrill Schell, April 1913
Vintage gelatin silver print, 240 x 190mm
• NPG P1698
Rupert Brooke (1887–1915) became celebrated for his striking good looks, charm and literary promise. He joined the Royal Navy at the outbreak of the First World War, later writing the war poems that made him famous, including 'The Soldier' (1914), which begins 'If I should die, think only this of me:/ That there's some corner of a foreign field/That is for ever England.' Their publication coincided with his early death from septicemia, while on his way to join the campaign at Gallipoli.

EMMELINE PANKHURST
(Mary) Olive Edis (Mrs Galsworthy), 1920s
Sepia-toned platinotype 153 x 99mm
• NPG x4332
Brought up in a large, politically active family on the outskirts of Manchester, from an early age Emmeline Pankhurst (1858–1928) was acutely aware of the inequalities faced by women. Shortly after leaving school she began working for the suffrage movement and founded the Women's Social and Political Union (WSPU) in 1903. In 1918 women over twenty-one years were given the vote. Pankhurst died in 1928, one month before the 1918 bill was extended to give women the vote on equal terms with men.

VIRGINIA WOOLF
G.C. Beresford, 1902
Platinum print, 152 x 108mm
• NPG P221
Virginia Woolf (1882–1941) was a central figure in the Bloomsbury Group, the circle of writers, artists and intellectuals that from the first decade of the twentieth century challenged convention. In 1908 she declared 'I shall reform the novel', and the essence of her literary achievement, which includes the novels *Mrs Dalloway* (1925), *To the Lighthouse* (1927), *Orlando* (1928) and *The Waves* (1931), is to have shifted fiction away from its conventional reliance on character and plot, focusing instead on interior experience, thoughts and impressions.

LYTTON STRACHEY
Dora Carrington, 1916
Oil on panel, 508 x 609mm • NPG 6662
Dora Carrington (1893–1932) painted this portrait of the writer and critic Lytton Strachey (1880–1932) at the beginning of their devoted, if unconventional, relationship. Strachey, a member of the Bloomsbury Group, was learned, literary, homosexual and older than Carrington, who had studied at the Slade School of Fine Art. Nevertheless, from 1917 they lived together, and the pair became a ménage à trois when they were joined by Ralph Partridge, whom Carrington married in 1922. Seven weeks after Strachey's death, the distraught Carrington committed suicide.

RADCLYFFE HALL
Charles Buchel, 1918
Oil on canvas, 914 x 711mm • NPG 4347
Believing herself to be a man trapped in a woman's body, the novelist Radclyffe Hall (1880–1943) cultivated the masculine appearance captured in this portrait. A lesbian and a professed 'congenital invert', Hall fell in love with Una Troubridge, and from 1918 until Hall's death the two lived together. Reflecting Hall's campaigning support for homosexuals, her fifth novel, *The Well of Loneliness* (1928), provoked controversy and was banned in England following a trial for obscenity.

SELF PORTRAIT (DAME LAURA KNIGHT)
Self-portrait, 1913
Oil on canvas, 1524 x 1276mm
• NPG 4839
Nottingham-born Laura Knight (1877–1970) was one of the most popular artists in Britain in the twentieth century. Her diverse subjects include the Cornish coast, the ballet and circus, Gypsy communities and, as a war artist during the Second World War, air crews and munitions workers. She was the first artist to be made a Dame (1929) and the first woman to be elected a full member of the Royal Academy of Arts (1936). This self-portrait is a defining work in Knight's career.

THOMAS EDWARD ('T.E.') LAWRENCE
Augustus John, 1919
Pencil, 356 x 254mm • NPG 3187
Intelligence officer and author T.E. Lawrence (1888–1935) – known as 'Lawrence of Arabia' – achieved notoriety as a First World War hero who helped liberate the Arabs from Turkish rule. Lawrence's account of his career, *Seven Pillars of Wisdom* (1926), features a reproduction of this portrait, the first of several drawings and paintings made of Lawrence by Augustus John (1878–1961). It was apparently finished

in two minutes while Lawrence was looking out of a window in the artist's apartment in Paris.

SIR WINSTON CHURCHILL
Sir William Orpen, signed 1916
Oil on canvas, 1480 x 1025mm
• Lent by Trustees of the Churchill Chattels Trust, 2012 • NPG L250
This haunting portrait of Winston Churchill (1874–1965), who would become one of Britain's best-known prime ministers, was painted during the official investigation into one of the most disastrous naval campaigns of the Great War. Churchill resigned his position as First Lord of the Admiralty over Britain's catastrophic attempt to conquer the Dardanelles Straits, and, having lost his reputation, feared he would never again take public office. Of this portrait, Churchill said, 'It is not the picture of a man, it is the picture of a man's soul.'

ALAN ALEXANDER ('A.A.') MILNE WITH CHRISTOPHER ROBIN MILNE AND POOH BEAR
Howard Coster, 1926
Vintage bromide print 219 x 257mm
• NPG P715
This classic photograph, taken to coincide with the publication of *Winnie-the-Pooh* in October 1926, shows its author A.A. Milne (1882–1956) with his son Christopher (1920–96) and the teddy bear that inspired the story. Following the success of *When We Were Very Young* (1924), Milne's first collection of children's poems, the *Evening News* asked him to write a piece for the newspaper; his response was an adaptation of a bedtime story he had created for Christopher, based around his teddy bear.

ELISABETH WELCH
Humphrey Spender, June 1933
Vintage bromide print, 200 x 147mm
• NPG x14268
Born in New York, singer Elisabeth Welch (1904–2003) made her stage debut in 1922. She helped to launch the Charleston on Broadway and popularised Cole Porter's scandalous 'Love for Sale'. In 1933 Welch began a sixty-year career in British musical theatre. Ivor Novello wrote songs for her, Paul Robeson was her leading man in films, and in the post-war years Welch starred in several stage plays. Later, in 1979, her appearance in Derek Jarman's film of Shakespeare's *The Tempest* (singing 'Stormy Weather') won her new fans.

1933 (ST RÉMY-SELF-PORTRAIT WITH BARBARA HEPWORTH) (BEN NICHOLSON AND DAME BARBARA HEPWORTH)
Ben Nicholson, 1933
Oil on canvas, 273 x 168mm • NPG 5591
This double portrait by Ben Nicholson (1894–1982) celebrates his close relationship with Barbara Hepworth (1903–75). The two were among the leading British avant-garde artists of the 1930s. In 1932, a year after they met, they shared a studio in Hampstead and had a joint exhibition, which demonstrated their progress towards abstraction. Trips to Paris brought them into contact with numerous artists, dealers and critics, and in 1933 they joined Unit One, the British group of painters, sculptors and architects that included Henry Moore. Nicholson and Hepworth married in 1938.

CHRISTOPHER ISHERWOOD AND WYSTAN HUGH ('W.H.') AUDEN
Louise Dahl-Wolfe, 1938
Vintage bromide print, 250 x 206mm
• NPG x15194
The novelist Christopher Isherwood (1904–86) and the poet W.H. Auden (1907–73) first met at school in Surrey and, after being reintroduced in London in late 1925, became lifelong friends, literary collaborators and, intermittently, lovers. In July 1938, on their return from a trip to China and Japan, they spent two weeks in New York, where this portrait was taken for *Harper's Bazaar*. Exhilarated by America, they returned in January 1939, and became American citizens in 1946.

DYLAN THOMAS
Augustus John, *c*.1937–8
Oil on canvas, 457 x 337mm • Lent by executors of Mrs Niel Gordon Clark, 1996
• NPG L213
Oil on canvas, 457 x 337mm
The poet Dylan Thomas (1914–53) was born in Swansea, and much of his writing evokes his early life in Wales. As his literary reputation grew in the early 1930s, Thomas gravitated to bohemian circles in London, where he met the painter and fellow Welshman Augustus John (1878–1961), who introduced Thomas to his future wife, Caitlin Macnamara. From 1940 Thomas wrote scripts for the BBC and worked as a broadcaster, but was increasingly affected by alcoholism. He completed the radio play *Under Milk Wood* in May 1953, shortly before his death in New York.

SIR PETER PEARS AND BENJAMIN BRITTEN, BARON BRITTEN
Kenneth Green, signed and dated 1943
Oil on canvas, 715 x 969mm • NPG 5136
In this double portrait the composer Benjamin Britten (1913–76) is depicted with the singer Peter Pears (1910–86), with whom he had a close personal and musical relationship that lasted from 1939 until Britten's death. They became a celebrated voice and piano duo, with Britten writing a stream of works for Pears's voice. By the time of this portrait Britten was forming ideas for one of his greatest works, the opera *Peter Grimes* (1945).

THOMAS STEARNS ('T.S.') ELIOT
Patrick Heron, signed and dated 1949
Oil on canvas, 762 x 629mm • NPG 4467
Early in 1947, Patrick Heron (1920–99), then a relatively unknown painter, wrote to T.S. Eliot (1888–1965), author of *The Waste Land* (1922) and *Four Quartets* (1943), asking whether he would be willing to sit for a portrait. Encouraged by the positive response, on 4 March 1947 Heron visited the literary giant in his office at the publishers Faber and Faber, where he was a director, to make a drawing from life. Subsequent drawings from life, and related experimental studies, underpinned a progressively abstracted image incorporating a double profile.

TED HUGHES
Sylvia Plath, *c.*1957
Pen and ink, 213 x 130mm
• NPG 6739
Poet Laureate from 1984, Ted Hughes (1930–98) was awarded the Whitbread Award for *Birthday Letters* (1998), a collection of poems, composed over a quarter of a century, addressed to the American poet Sylvia Plath (1932–63),

his first wife. As a poet, Plath's reputation is commensurate with Hughes', and her work includes *The Bell Jar* (1963) and *Ariel*, published posthumously in 1965, following her suicide. Plath's intimate portrait of Hughes, probably sketched on a page of her journal, was made a year into their marriage.

BRIDGET RILEY
Ida Kar, 1963
Original film negative • NPG x127158
Bridget Riley (b.1931) studied at Goldsmith's College and the Royal College of Art. The leading exponent of Op Art in Britain, she won the International Prize for Painting at the 1968 Venice Biennale, the first British painter and female artist to achieve this distinction. Her meticulously executed paintings engage with visual sensation, and until 1980 were mainly concerned with generating perceptual experiences. Of Armenian origin, Ida Kar (1908–74) established her photographic practice in 1933 in Cairo, and moved to London in 1945. Kar photographed Riley at her second exhibition at Gallery One, in September 1963.

CHRISTINE KEELER
Lewis Morley, 1963
Bromide print, 508 x 413mm
• NPG P512(13)
At the age of sixteen, model and showgirl Christine Keeler (b.1942) left her Berkshire home for London, and in 1960 was employed at Murray's cabaret club in Soho. Here she met society osteopath Stephen Ward, who introduced her to the Conservative Minister of War, John Profumo, and Yevgeny Ivanov, the Soviet naval attaché. Affairs with both provoked a major political scandal in 1963. This famous portrait of Keeler by

Lewis Morley (1925–2013), taken at the height of the Profumo affair, has become a defining image of the 1960s.

DAVID BOWIE
David Wedgbury, 1966
Resin print, 270 x 267mm • NPG x47344
Born David Robert Jones in Brixton, south London, singer-songwriter David Bowie (1947–2016) gained recognition with his single 'Space Oddity' (1969), the release of which coincided with the first moon landing. He achieved international fame with his rock albums *The Rise and Fall of Ziggy Stardust and the Spiders from Mars* (1972) and *Aladdin Sane* (1973). Bowie's music career spanned more than four decades, and was characterised by continual reinvention and experimentation. Also recognised as an actor, he became one of the most influential figures in modern British popular culture.

HAROLD WILSON, BARON WILSON OF RIEVAULX
Ruskin Spear, *c.*1974
Oil on canvas, 511 x 381mm • NPG 5047
Depicted with his trademark pipe, the twice-elected British prime minister Harold Wilson (1916–95) is depicted in this portrait by Ruskin Spear (1911–90) as many of his detractors saw him: a populist politician with a down-to-earth style, yet with an elusive, even evasive personality. Spear portrayed Wilson on several occasions. This portrait, the sittings for which took place in Downing Street, was exhibited in the year that Wilson returned to the premiership following his general election victory in October 1974.

MAN'S HEAD (SELF-PORTRAIT III) (LUCIAN FREUD)
Self-portrait, 1963
Oil on canvas, 305 x 251mm • NPG 5205
Artist Lucian Freud (1922–2011) was born in Berlin, the grandson of Sigmund Freud, and emigrated to England with his family in 1933. In the late 1950s Freud dropped his early, precise style of painting in favour of a looser, more expressive approach, using hog's hair brushes to build a heavily impastoed surface over many hours spent observing his sitters. In this self-portrait, Freud turned his characteristically close scrutiny upon himself.

QUEEN ELIZABETH II
Andy Warhol, 1985
Silkscreen print, 1000 x 800mm
• NPG 5882 (3)
This portrait of Queen Elizabeth II (b.1926) is one of four colour variants of the same image, the set forming part of a larger series of sixteen screen prints by Andy Warhol (1928–87) titled *Reigning Queens*. An initiator of Pop Art in the 1950s and 1960s, Warhol used photography to create secondary images. The abstracted nature of this portrait, which is based on the official Silver Jubilee photograph taken by Peter Grudgeon in 1977, reflects Warhol's obsession with fame and the mechanisms by which celebrity is created and represented.

DOROTHY HODGKIN
Maggi Hambling, 1985
Oil on canvas, 932 x 760mm • NPG 5797
In 1964 crystallographer Dorothy Hodgkin (1910–94) became the first British woman to win the Nobel Prize for Chemistry. Fascinated with crystals from childhood, she was the first scientist to define the structure of penicillin (1942–9), vitamin B12 (1964) and insulin (1969) using X-ray diffraction photography. Hodgkin sat for Maggi Hambling (b.1945) in the study at the scientist's Warwickshire home (a structural model of insulin is on the table). Hambling noted that Hodgkin's hands were 'like busy animals, always on the go', and included two pairs of arms to evoke this energy.

DIANA, PRINCESS OF WALES
Bryan Organ, 1981
Acrylic on canvas, 1778 x 1270mm
• NPG 5408
The Gallery commissioned this portrait of Diana, Princess of Wales (1961–97) from artist Bryan Organ (b.1935) as a companion piece to his earlier portrait of Prince Charles (1980), in time for the Royal wedding on 29 July 1981. Upon its unveiling at the Gallery on 23 July the press responded in particular to the unusual depiction of a female member of the Royal Family wearing trousers, and on 29 August the portrait was slashed by a protestor. A successful restoration was quickly undertaken and the painting was returned to public display the following November.

HAROLD PINTER
Justin Mortimer, 1992
Oil on canvas 910 x 910mm • NPG 6185
Harold Pinter (1930–2008) was one of the most distinguished playwrights of his generation, and a respected director and actor. Born in Hackney, east London, his reputation was secured with *The Caretaker* (1960). *The Homecoming* (1965) and *No Man's Land* (1975) followed, evoking uncertainty and menace whilst revealing the poetry and comedy of everyday language. His screenwriting credits include *The Servant* (1962), *The Go-Between* (1970) and *Betrayal* (1978). He was awarded the Nobel Prize for Literature in 2005.

ALAN BENNETT
Derry Moore, 12th Earl of Drogheda, 1992
Fujichrome Print, 347 x 297mm
• NPG P525
Born in Leeds, Alan Bennett (b.1934) studied at the University of Oxford, where he performed with the Oxford Revue. His collaboration with Dudley Moore, Jonathan Miller and Peter Cook in the satirical revue *Beyond the Fringe* (1960) brought him instant acclaim. Notable successes on stage, screen and radio include *A Question of Attribution* (1988), *The Madness of George III* (1991), *The Lady in the Van* (2009) and *The History Boys* (2005), and the television monologues *Talking Heads* (1988).

PORTRAIT OF A S BYATT: RED, YELLOW, GREEN AND BLUE: 24 SEPTEMBER 1997 (DAME ANTONIA SUSAN ('A.S.') BYATT)
Patrick Heron, 1997
Oil on canvas, 968 x 1216mm
• NPG 6414
The novels of A.S. Byatt (b.1936) include *The Virgin in the Garden* (1978), the Booker Prize-winning *Possession* (1990) and *The Biographer's Tale* (2000). She is also a critic and essayist, writing on art history, literary history and philosophy. When the Gallery began discussions about a possible portrait, she expressed her admiration for Patrick Heron's portrait of T.S. Eliot (see page 119). Heron, still active in his studio in Cornwall, accepted the invitation to paint Byatt, and she wrote a compelling account of the process for the Gallery's records.

CONTEMPORARY

ALEX, BASSIST. DAMON, SINGER. DAVE, DRUMMER. GRAHAM, GUITARIST. (BLUR)
Julian Opie, 2000
C-type colour print on paper laid on panel, 868 x 758mm • NPG 6593 (1–4)
Damon Albarn (b.1968), Graham Coxon (b.1969), Alex James (b.1968) and Dave Rowntree (b.1964) formed Blur in 1989, and their chart-topping album *Parklife* (1994) announced the band's leading position in the era of Brit Pop. These portraits were originally commissioned by the band for the cover of their album *Blur: the best of* (2000). The artist Julian Opie (b.1958), whose graphic language is derived from signage and advertising, made 'digital drawings' by sketching on to photographs of the band and reducing their features to a minimum.

THOMAS ADÈS
Phil Hale, 2002
Oil on canvas, 2138 x 1073mm
• NPG 6619
Thomas Adès (b.1971) has achieved acclaim as composer, conductor and pianist, and was artistic director of the Aldeburgh Festival between 1999 and 2008. His works include *Asyla* (1997) for orchestra, the operas *Powder Her Face* (1995) and *The Tempest* (2004) and the piano concerto with video *In Seven Days* (2008). Canadian-born artist Phil Hale (b.1963) made numerous photographs, drawings and oil sketches over a seven-month period for this portrait, which is set in a corner of the sitter's London home.

ALFRED BRENDEL
Tony Bevan, 2005
Acrylic on canvas, 756 x 670mm
• NPG 6720

Alfred Brendel (b.1931) is one of the world's great pianists, with a career spanning over six decades. Now based in London, he was born in northern Moravia, and his early years were spent in Croatia and Austria. Largely self-taught, he made his first professional recording aged twenty-one and became a renowned interpreter of Beethoven, Mozart, Schubert, Brahms and Liszt. British painter Tony Bevan (b.1951), whose approach is rooted in the European expressionist tradition, was commissioned to paint Brendel after the pianist expressed admiration for the artist's work.

DAVID (DAVID BECKHAM)
Sam Taylor-Johnson (Sam Taylor-Wood), 2004
Digital film displayed on plasma screen
• NPG 6661
In his youth, Londoner David Beckham (b.1975) attended Bobby Charlton's football schools in Manchester and signed to play for Manchester United in 1991. During his time there, the team won the Premier League title six times, the FA Cup twice and the UEFA Champions League in 1999. He captained the England team for six years, and received an OBE in 2003. This video portrait by Sam Taylor-Johnson (b.1967) provides us with an unfamiliar view of a familiar figure: the usually dynamic Beckham in repose.

JOANNE KATHLEEN ('J.K.') ROWLING
Stuart Pearson Wright, 2005
Oil on board construction with coloured pencil on paper, 972 x 720mm
• NPG 6723
J.K. Rowling (b.1965) is the author of the successful Harry Potter series of books,

now translated into sixty-one languages with over a quarter of a billion copies sold worldwide. Rowling said that the characters and plot of the first novel, *Harry Potter and the Philosopher's Stone* (1997) came to her 'fully formed' during a train journey. This *trompe-l'oeil* portrait by Stuart Pearson Wright (b.1975) approaches the fictional worlds in Rowling's own work and references the café where Rowling wrote the first Harry Potter book.

DAME ZAHA HADID
Michael Craig-Martin, 2008
Wall-mounted LCD monitor with integrated software, 1257 x 749mm overall • NPG 6840
Iraqi-born, British-trained architect Zaha Hadid (1950–2016) founded her practice in London in 1979. Her neofuturist buildings, which include the London 2012 Olympic Aquatics Centre, the Maxxi Museum in Rome and the Rosenthal Centre for Contemporary Art in Cincinnati, are characterised by bold, visionary forms. Hadid won the Pritzker Architecture Prize in 2004 and the RIBA Stirling Prize in 2010 and 2011. The application of computer-aided graphics in this portrait by Michael Craig-Martin (b.1941) mirrors that of Zaha Hadid's in her architectural designs.

SIR WILLARD WHITE
Ishbel Myerscough, 2009
Oil on canvas, 762 x 562mm • NPG 6886
Born in Jamaica, the internationally acclaimed opera singer Willard White (b.1946) made his debut at the New York City Opera and is now based in London. He has sung all the major bass-baritone roles in the repertoire and performed with the world's leading conductors. The artist Ishbel Myerscough (b.1968) had

several sittings with White at his London home, later recalling that he 'would warm up his voice by exercising it as he walked around the house doing jobs, such as going to make a cup of coffee or adjusting the heating.'

SELF-PORTRAIT WITH CHARLIE (DAVID HOCKNEY)

Self-portrait, 2005
Oil on canvas, 1829 x 914mm
• NPG 6819

Artist, printmaker, stage designer, photographer and writer, Bradford-born David Hockney (b.1937) studied at the Royal College of Art and became a leading figure in the Pop Art movement before moving, in 1963, to California, where he found fresh inspiration. In recent years, Hockney has divided his time between California, London and East Yorkshire, and his projects have included the Royal Academy exhibition *A Bigger Picture* (2012). This self-portrait, made in Hockney's Hollywood Hills studio in 2005, features the artist with New York-based curator Charlie Scheips.

CATHERINE, DUCHESS OF CAMBRIDGE

Paul Emsley, 2012
Oil on canvas, 1152 x 965mm
• NPG 6956

Catherine Elizabeth Middleton, now Her Royal Highness The Duchess of Cambridge (b.1982), was born in Berkshire and married His Royal Highness Prince William at Westminster Abbey on 29 April 2011. In February 2012, St James's Palace announced her patronage of five charities, one of which is the National Portrait Gallery. For this portrait the Duchess sat for the artist Paul Emsley (b.1947) twice, at Kensington Palace and in his studio.

PRINCE HENRY ('HARRY') AND PRINCE WILLIAM, DUKE OF CAMBRIDGE

Nicola Jane ('Nicky') Philipps, 2009
Oil on canvas, 1374 x 1475mm
• NPG 6876

This is the first official portrait of Prince William (b.1982), the heir to the British throne, and Prince Harry (b.1984). It shows the brothers in the library of Clarence House and represents a unique moment in their lives; they were both serving officers in the Household Cavalry (Blues and Royals) and are depicted wearing the regiment's dress uniform. While working in the tradition of historic royal portraiture, the artist Nicky Philipps (b.1964) conveys what she describes as an 'informal moment within a formal context' for this Gallery commission.

SHAMI CHAKRABARTI

Gillian Wearing, 2011
Gelatin silver print, 929 x 800mm
• NPG 6923

Born in London of Indian heritage, Shami Chakrabarti (b.1969) was the director of the human-rights pressure group Liberty between 2003 and 2016, becoming a spokesperson for issues relating to civil liberties. Chakrabarti is portrayed holding a wax mask sculpted from a digital scan of her own face. The mask is a feature of the work of Turner Prize-winning artist Gillian Wearing (b.1963), which explores the disparity between public and private identities. For this portrait, however, the idea was prompted by the sitter, who perceives her public persona as mask-like, often interpreted as 'grim', 'worthy' and 'strident'.

PICTURE CREDITS

Published in Great Britain by National Portrait
Gallery Publications St Martin's Place, London
WC2H 0HE

For a complete catalogue of current publications, please
write to the National Portrait Gallery at the address above,
or visit our website at www.npg.org.uk/publications

ISBN 978 1 85514 700 3

A catalogue record for this book is available from
the British Library.

10 9 8 7 6 5 4 3 2 1

Printed in Italy

Managing Editor: Christopher Tinker
Production Manager: Ruth Müller-Wirth
Production and Editorial: Kathleen Bloomfield
Designer: Peter Dawson, www.gradedesign.com

ACKNOWLEDGEMENTS
The National Portrait Gallery Collection has grown
through the generosity of many institutions, families and
individuals who have donated important works. Equally
important has been the support over many decades of the
Art Fund (formerly known as the National Art Collections
Fund), and in more recent years of the National Heritage
Memorial Fund and the Heritage Lottery Fund. The
Gallery's own Portrait Fund has become increasingly
significant, and the National Portrait Gallery is very
grateful to all those who have supported the Fund as well
as the public campaigns to acquire particular portraits.

PAGE 2
KING RICHARD III
Unknown English artist, late 16th century,
after a portrait of the 15th century